IMAGES
of America

LINCOLN IN BLACK AND WHITE
1910–1925

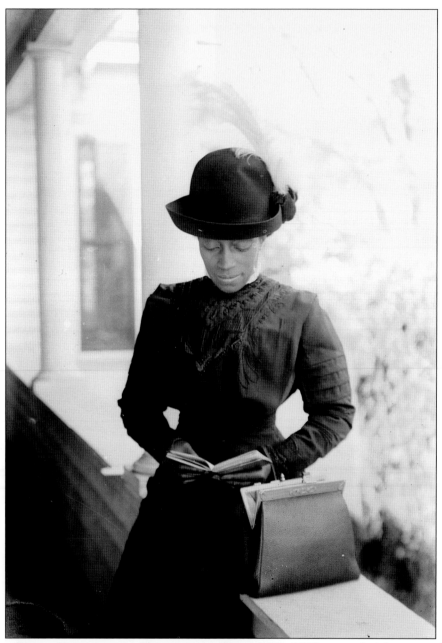

LEONA DEAN, HAIRDRESSER. Elegant Leona Dean (1879–1958) was a hairdresser, and her husband, James (1876–1959), worked at Lincoln Country Club. Her younger brother was Clyde Malone (see cover and page 74). This photograph was not taken at the Deans' small house at Ninth and Rose Streets, which did not feature the large porch where this portrait and at least three other photographs were taken (see pages 96 and 97). Instead, the photographer may have set this scene in the well-lit shade of a big porch kitty-corner from the Deans, at the house of William Cotton, a letter carrier.

On the cover: See also page 74. (Keister collection.)

IMAGES
of America

LINCOLN IN BLACK AND WHITE
1910–1925

Douglas Keister and Edward F. Zimmer

ARCADIA
PUBLISHING

Published by Arcadia Publishing
Charleston SC, Chicago IL, Portsmouth NH, San Francisco CA

Printed in the United States of America

Library of Congress Catalog Card Number: 2008925383

For all general information contact Arcadia Publishing at:
Telephone 843-853-2070
Fax 843-853-0044
E-mail sales@arcadiapublishing.com
For customer service and orders:
Toll-Free 1-888-313-2665

Visit us on the Internet at www.arcadiapublishing.com

To Ruth Talbert Greene Folley. Without a classroom, always a teacher.
And to those who preserve the past to better our future.

CONTENTS

Acknowledgments 6

Introduction 7

1. City Streets 9

2. Gathered Outdoors 27

3. People, Porches, and Pets 39

4. Families and Friends 57

5. Portraits 73

6. Welcome Inside 119

Notes on the Collection 125

ACKNOWLEDGMENTS

Without a word of text, the images in this book speak eloquently of human dignity and beauty. But these photographs are more than works of visual art—they depict a real place and real people. Through the generous assistance of many elders of the African American community of Lincoln and diligent research, many of the images have been reunited with life stories of actual people, revealing these beautiful pictures as powerful historical documents.

Kathryn Colwell Hill laid the foundation for the research with her master's project in the Community and Regional Planning Program of University of Nebraska–Lincoln, working as an intern in the Lincoln-Lancaster County Planning Department. Abigail Anderson, also a graduate planning student and intern, built on that base and developed encyclopedic knowledge of the community and the photographs, especially through invaluable oral histories. Her continuing collaboration has been essential to this work. Kara Harms contributed diligently and creatively to the research. At the Nebraska State Historical Society, John Carter, Bob Puschendorf, Lynne Ireland, and Deborah Arenz played key roles. In the Lincoln-Lancaster County Planning Department, Steve Henrichsen and Marvin Krout have recognized the value of a project that has stretched the bounds of typical municipal preservation planning.

All these efforts would have yielded a meager harvest except for the generosity of African American elders and their families who shared memories and photographs of their forbearers and community. Ruth Folley offered insightful memories that spanned nine decades. The McWilliams family, including Margaret, Victor and Juanita, Art and Joan, Jon D., Victor Jr., Henry, Theresa, Karen, and Alyce McWilliams Hall, generously shared information, guidance, photographs, and treasured family artifacts. Jeanne Malone Freels, Pamona Banks James, the Patrick sisters (Ruth Thomas, Betty Gaines, and Helen Seward), Charlotte Jackson, and Rick Wallace each made unique contributions. Despite their generous assistance and that of so many others, many of the individuals photographed remain unidentified and some I have probably misidentified. Hopefully more families will come forward to share their knowledge and their photographs, with tolerance for the mistakes made, which are my own.

—Edward F. Zimmer

I wish to thank Axel and Doug Boilesen, the original sleuths who uncovered the collection; my eagle-eyed mother, Katherine Keister, who spied the article about the first discovery of the negatives; and most of all to my wife, Sandra McLean, who kept encouraging me to find a way to bring the collection to the public.

—Douglas Keister

INTRODUCTION

The Nebraska Territory was only five years old in 1859 when a few settlers in the southeast part of the territory organized Lancaster County and platted a county seat of the same name on the east banks of Salt Creek. The county and the town were named for Lancaster County, Pennsylvania, the home of one of the settlers. The little settlement had only a few dozen residents in 1867 when Nebraska was admitted as a state and Lancaster, renamed Lincoln after the assassinated president, was chosen as the state capital. The capital location was a victory for out-state legislators over Omaha's interests. Omaha, the state's largest city and former territorial capital, was viewed as too remote from the rest of the state in its location on the eastern boundary. Lincoln, 55 miles southwest, was felt to be more "central" in a state over 450 miles wide.

A substantial town site was platted for the capital, with wide streets, parkland, a campus for the yet-to-be-founded state university, and an ample Capitol Square. By locating not only the state government in Lincoln but also the other major state institutions—the university, the penitentiary, and the insane asylum—an economic base for the new city was provided.

Lincoln's population of 2,441 in 1870 included only 15 African American residents, but by 1871, this small group had already begun to organize an African Methodist Episcopal church. Two more black churches grew in the 1880s and 1890s, as the city's population reached 55,000 by 1890, including about 1,400 African Americans. The African American community was a small percentage of the overall population but was large enough to constitute a small town within the growing city. The boomtown attracted young men who would have national impact around the dawn of the 20th century, including William Jennings Bryan, three-time presidential candidate, and a young military instructor at the University of Nebraska, John Jay Pershing. Lincoln also attracted men like former slave, Civil War veteran, and homesteader John McWilliams, his wife, Sarah, and their eight children, from whom six generations of Lincoln preachers, teachers, janitors, and managers have grown.

Lincoln lost population from all sectors of the community in the economic depression of the 1890s, but the new century brought growth to the economy and to the population. At the beginning of the era depicted by the photographs in this book (1910–1925), Lincoln had a population of about 44,000, of whom 7,200 were foreign-born, and 733 had African ancestry. By the mid-1920s, about 900 African American residents constituted a tiny 1.5 percent of the city's population of 60,000.

Race relations in Lincoln apparently deteriorated during the second decade of the 20th century. The open public education system continued to attract families, but residential choices were narrowing and Lincoln land developers began to insert racist covenants into deeds in 1916. Employment opportunities were especially restricted to menial and service jobs. The

best-educated black young people typically left Lincoln for better opportunities elsewhere. When some returned, such as Millard T. Woods and Clyde Malone, they combined local connections and education with experiences from other regions and larger cities, to the great benefit of Lincoln.

A Lincoln chapter of the National Association for the Advancement of Colored People (NAACP) was formed in 1918 by local leaders such as William Woods, Rev. O. J. Burckhardt, and Trago T. McWilliams. In the 1920s, Lincoln was home to a fast-growing klavern of the second Ku Klux Klan, which targeted blacks, Jews, Catholics, and immigrants. In Lincoln, as nationwide, that hate group declined in the late 1920s nearly as quickly as it had arisen.

It was in this environment that John Johnson, a graduate of Lincoln High School and the son of an escaped slave and Civil War veteran, served as his community's photographer from around 1910 to 1925. This book is drawn from the largest known collection of Johnson's glass-plate negatives, over 250 images in the possession of Douglas Keister, a Lincoln native of German ancestry who is an author and professional photographer in Chico, California. Keister's collection makes up roughly half of the negatives and/or vintage prints that can be attributed to Johnson.

The text of this book attempts to provide the context, the real time and place, in which Johnson created his art and his subjects offered themselves to the camera's scrutiny. Many of the people in Johnson's images are still unidentified, which makes the art of the photographs no less evocative. But the real stories, when we know them, are like the string on a kite—the images soar higher for being tethered to reality.

One

CITY STREETS

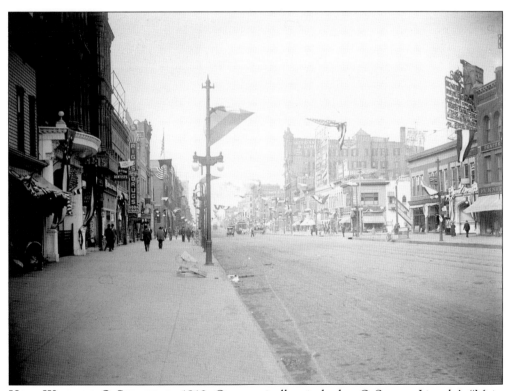

VIEW WEST ON O STREET, C. 1910. On a typically windy day, O Street—Lincoln's "Main Street"—appears to be decked out for the Fourth of July. The camera was positioned on the south sidewalk near Fourteenth Street, looking west. The tall building at the center of the view was the six-story Burr Block, Lincoln's first "skyscraper," built in 1888.

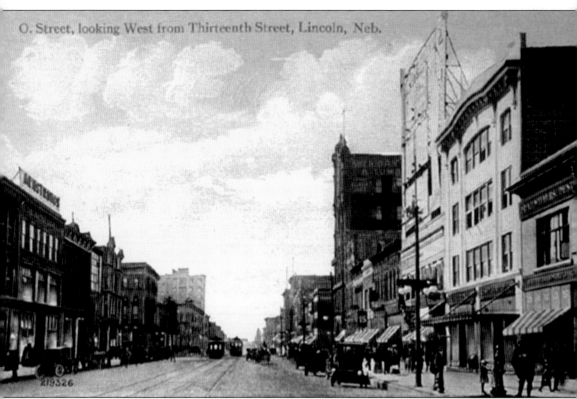

O. Street, looking West from Thirteenth Street, Lincoln, Neb.

POSTCARD VIEW WEST ON O STREET, C. 1913. In the early 20th century, the Lincoln Chamber of Commerce boasted of "a new skyline every morning." The four-story building at right was brand-new in 1913 and had not yet been built in the view on page 9. In the left foreground are the buildings soon to be replaced by the Miller and Paine Department Store in 1914 and 1916, as depicted on pages 12 and 13.

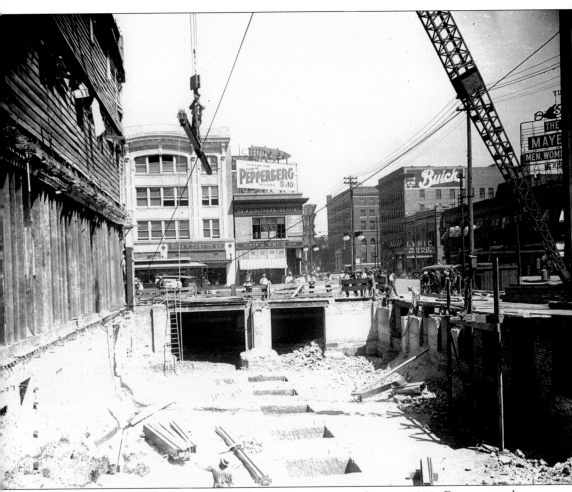

EXCAVATION FOR THE MILLER AND PAINE DEPARTMENT STORE, 1914. Few events drew
spectators and photographers like construction. John Johnson positioned himself in an alley for
a view north across the basement for the Miller and Paine Department Store, under construction
in 1914 at Thirteenth and O Streets. The growing company had operated for several years in
existing buildings at this corner. With its new construction, the department store established
Thirteenth and O Streets as Lincoln's retail center for most of the century. The Pepperberg
billboard atop the building across O Street advertises a local cigar maker.

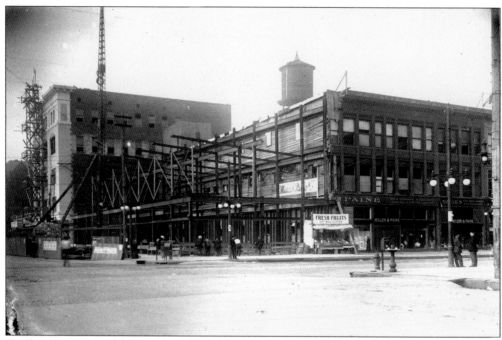

CONSTRUCTION OF MILLER AND PAINE DEPARTMENT STORE, 1914. When the department store decided to replace its rented quarters at Thirteenth and O Streets with a new building, the property owner offered a 99-year lease to the ground but would not sell the site outright. The store cautiously built only two stories on the leased ground. Two years later in 1916, the company added eight stories on the next lot to the west, which it was able to purchase. Both structures were designed by the Lincoln architects Berlinghof and Davis, using buff brick and gleaming white terra-cotta trim. A sidewalk vendor is offering fresh fruits in front of the construction site. The postcard shows the store around 1920.

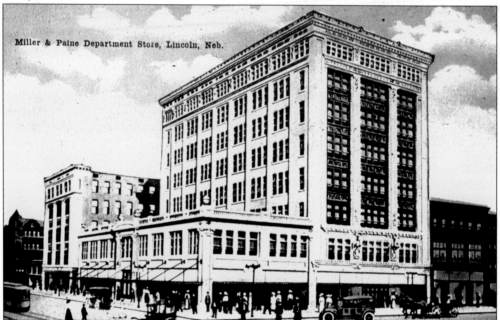

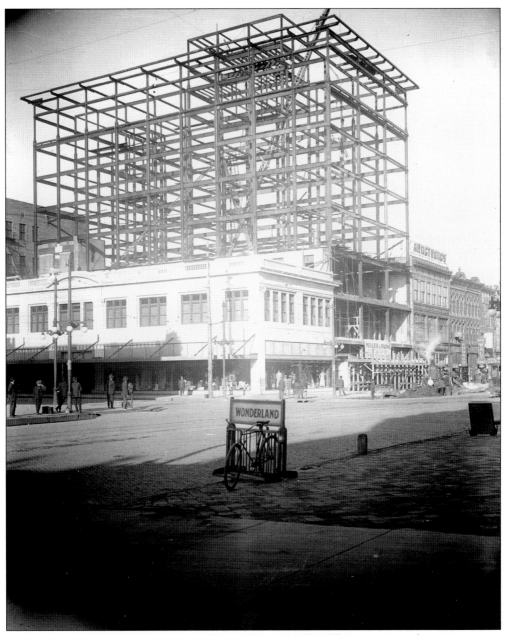

CONSTRUCTION OF THE MILLER AND PAINE TOWER, 1916. This summer early-morning view catches the east (left) and north (center) faces of the Miller and Paine Department Store in full light. The bicycle rack in the foreground advertises Wonderland, a movie theater kitty-corner across the intersection from the department store. The new eight-story tower, including its wide projecting cornice, is shown fully framed, awaiting its walls of brick and rich terra-cotta ornament. Miller and Paine became Lincoln's premier and longest-lasting local department store until Dillard's purchased the business in the 1980s. The handsome, refurbished buildings now provide office space.

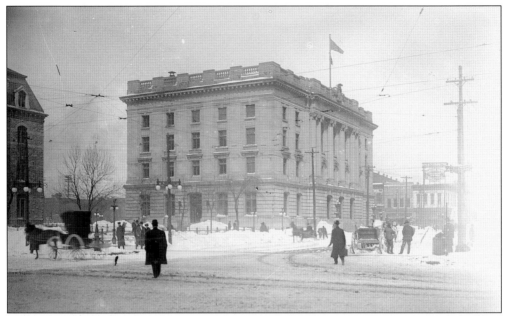

United States Courthouse and Post Office, Lincoln, 1910–1915. No single building figures more prominently in John Johnson's photographs than the new downtown post office at the center of this snowy view of Government Square. The building at the left was the earlier courthouse and post office, built in the 1870s. The federal government sold "Old City Hall" to the City of Lincoln, which used it as the seat of municipal government from 1905 to 1969.

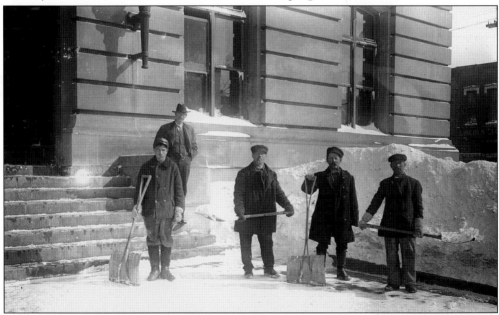

Snow Shovelers at the Post Office. John Johnson was listed in city directories as a laborer or janitor at the post office on and off from 1904 to 1917. When he resigned in 1917, his pay was $600 per year. He often photographed his workmates, here taking a break from shoveling a deep snowfall. They stand outside the south entrance, which was in-filled with a window in the remodeling and extension of 1914–1916.

14

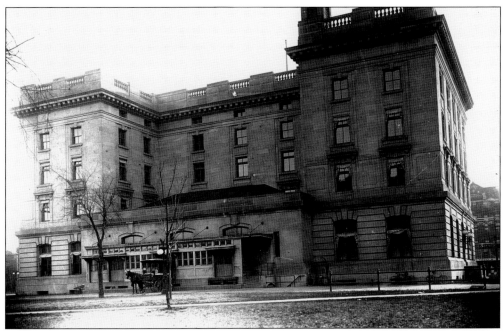

WEST SIDE OF THE POST OFFICE, BEFORE 1915. James Knox Taylor, as the supervising architect of the U.S. Treasury, designed Lincoln's new neoclassical courthouse and post office in 1905. The main entrance faced Tenth Street on the east, while the west side fronted on a public park and provided a covered dock for wagons to load and unload the mail.

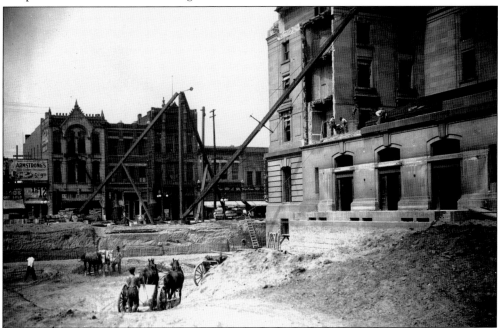

CONSTRUCTION AT THE POST OFFICE, 1915. Just a decade after Lincoln's new post office was constructed, the growing city needed a larger facility. In 1915–1916, the building was doubled in size with an addition to the west side, which closely followed the design of the 1905 building (as did a final wing at the west end that completed the block-long building in 1939).

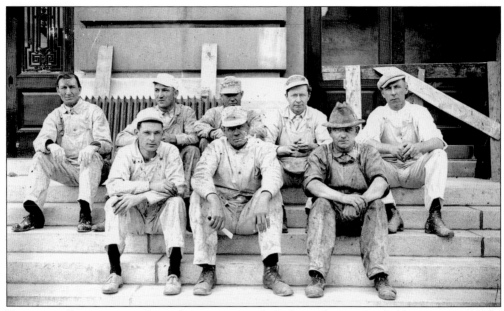

BUILDING CREW AT THE POST OFFICE, C. 1915. Eight workmen—probably painters—sit for a portrait on the east, main steps of the post office during the construction of 1915–1916. That project extended the original post office and rearranged much of the ground floor of the 1905 building. The lobby today retains marble wainscoting and oak trim from 1905, but in positions to which those fine finishes were relocated in 1915.

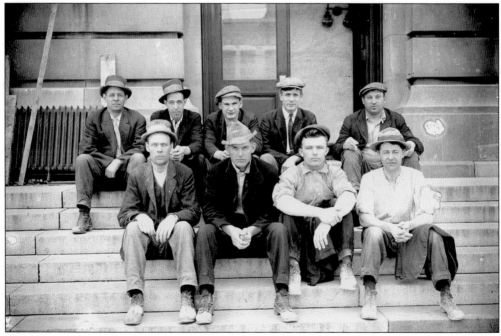

WORKMEN AT THE POST OFFICE, C. 1915. Nine more workmen pose in front of a half-open door, showing a light fixture inside. While most of the men wear coats and a few wear ties, their well-worn boots and mix of caps and hats suggests that these are not office workers. The steam radiator at left was removed during the remodeling and awaits reinstallation.

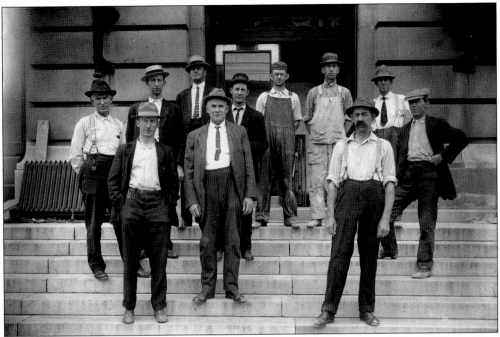

EMPLOYEES AT THE POST OFFICE, C. 1915. This mixed group appears to include office workers and other laborers. A carpenter in the back row has a hammer hanging from a loop in his overalls. The upper floors of the original building, including a handsome courtroom on the third floor, were largely unaltered during the addition of the second wing and perhaps remained in use throughout construction.

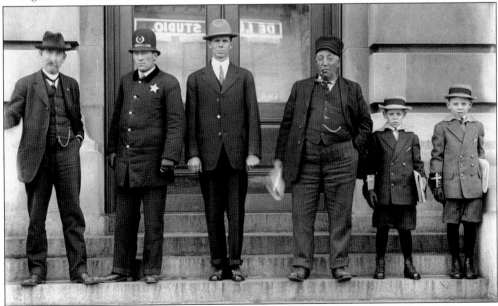

COURTHOUSE DENIZENS, C. 1915. The north steps of the post office are the setting for this group portrait, which includes a policeman and two newsboys. Mirrored in the glass doors is a sign for Deluxe Studio, a photographer's establishment north across P Street from the courthouse. John Johnson's care in composing images suggests he was probably aware of this reflection.

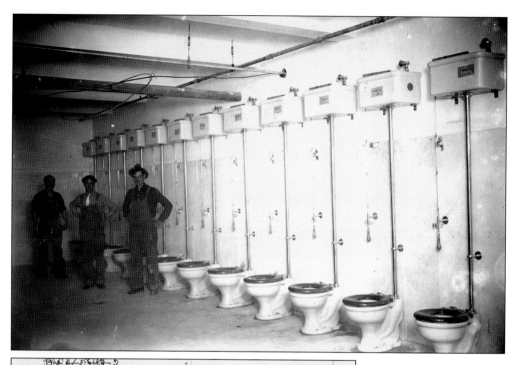

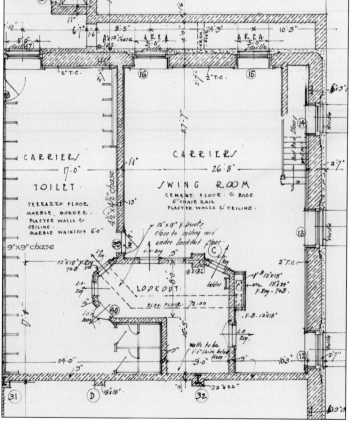

MAIL CARRIERS' TOILET ROOM. The building plans of 1914 for the expansion to Lincoln's courthouse and post office include a "Carriers Swing Room" in the basement adjacent to the "Carriers Toilet." The latter room was planned and built with 14 toilets arranged along one wall, as well as marble wainscoting. The lack of privacy was quite deliberate—both of the carriers' rooms and many parts of the post office included a "lookout" for covert surveillance by postal inspectors, intended to prevent theft from the mail. John Johnson worked as a janitor in the federal building. This image might be one that only a janitor/photographer would have taken.

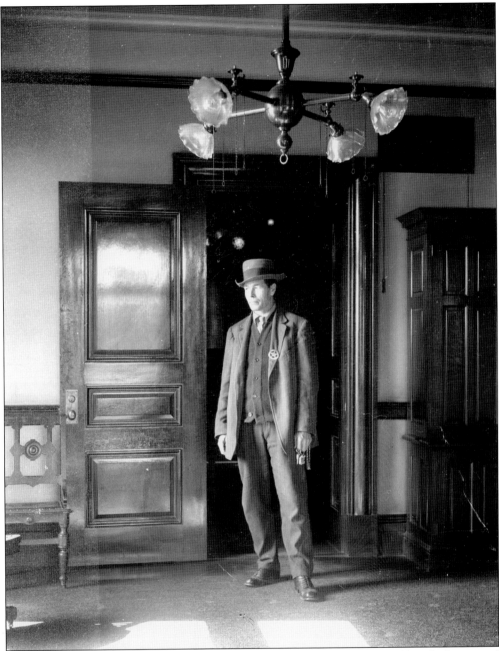

COURTHOUSE LAWMAN. Although not in uniform, this lawman is identified by a badge pinned to his vest. The bunch of keys in his hand suggest he may have been the turnkey in charge of the holding cells associated with the courtroom. The light fixture over his head provides both electricity and gas illumination. Lincoln began electric service in the late 1880s, but many homes and offices had combination fixtures for greater reliability.

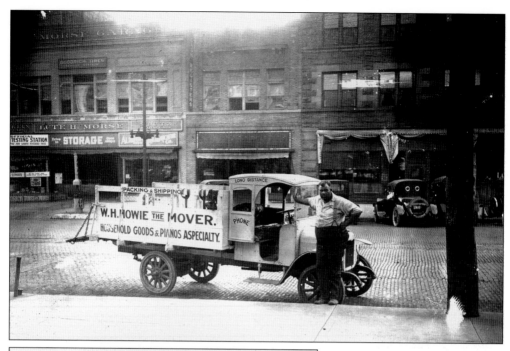

PATRIOT TRUCKS

What They Did at Walla Walla

A few weeks ago a big Farm Power Demonstration was held at Walla Walla, Wash., attended by about 40,000 people. At this Demonstration Patriot Trucks were the only rear-driven trucks that went over the hills in the plowed ground under full loads.

In fact, the performance of the Patriot over plowed ground, rough country roads and mountain trails was so wonderful that the International "Movie Man" followed it with his camera and Patriot Trucks were featured in motion pictures all over the country.

We are interested in making connections with distributers and dealers who want a line of Trucks that will deliver unusual truck service.

HEBB MOTORS CO.
Manufacturers
1391 P Street Lincoln, Neb.

The illustration shows the Patriot Lincoln Model Truck, 1½ tons' capacity, equipped with one of our farm bodies. For hauling fine stock, the sides may be raised, leaving space between the side boards, providing for ample height.

When Writing to Advertisers, Please Mention Motor Age

HOWIE THE MOVER. Will H. Howie was photographed with his moving truck on the west side of Government Square around 1923. Howie was born in 1885 to an English mother and Scottish father. He moved pianos and was a driver for various Lincoln transfer companies before operating a business in his own name in the early 1920s. Howie's truck appears to be the Revere model assembled by Hebb Motors of Lincoln. In 1919 and 1920, Hebb manufactured Patriot Trucks on Ford chassis in Havelock, adjacent to Lincoln. (Left, courtesy of Nebraska State Historical Society, from *Motor Age*, June 12, 1919.)

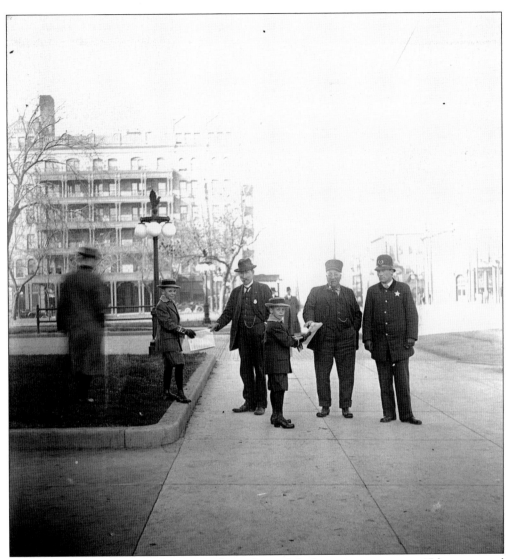

NEWSBOYS AND PATRONS. The men and newsboys of the lower image on page 17 have stepped down from the courthouse entrance to pose in the act of selling their papers on the sidewalk north of the courthouse and post office. The office of the Lincoln *Journal* newspaper (*Nebraska State Journal* in the 1860s, *Lincoln Journal Star* in 2008) was located across P Street to the north of the courthouse and post office since the 1880s and remains there today. Lincoln Hotel is in the left background, west across Ninth Street from Government Square. The light pole with four globes has a bronze eagle finial with raised wings. Those lights were installed around Government Square in 1907.

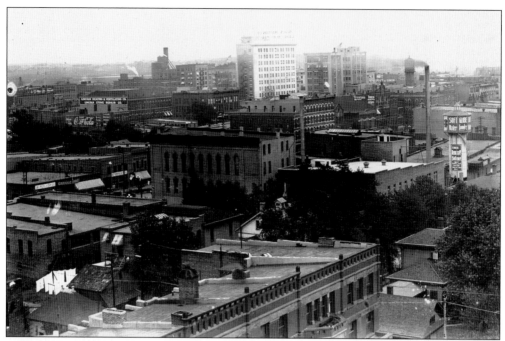

Aerial View of Downtown Lincoln. The photographer's perch for this cityscape was the Metropolitan Apartments, an eight-story structure built in 1916 at Twelfth and K Streets. In the foreground is Baldwin Terrace, one of Lincoln's few row houses built in the 1880s. The tall white office building at the center of the horizon is the Terminal Building, built by Lincoln Traction Company as the terminus of its streetcar system in 1916.

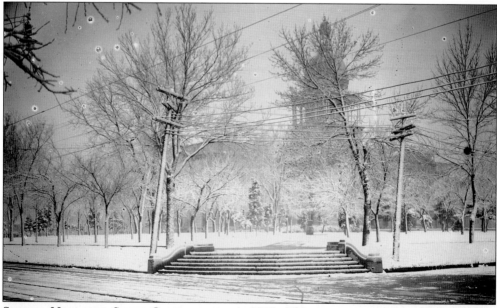

Second Nebraska State Capitol, before 1922. This view across snowy Capitol Square appears to be taken from Sixteenth and K Streets. Behind the trees is the tower of the second Nebraska State Capitol, built in the 1880s and replaced between 1922 and 1932 by the present capitol with its 400-foot tower.

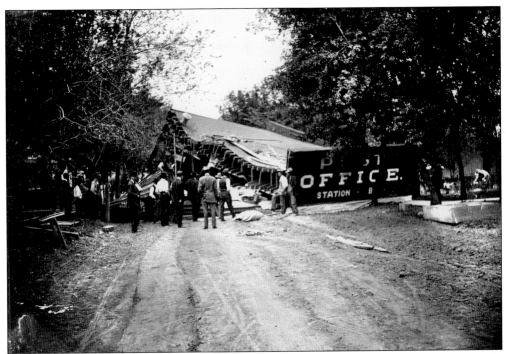

THE COLLAPSE OF STATION B. Disasters draw gawkers and photographers even more surely than construction sites. Here post office Station B at South Seventeenth and Garfield Streets has collapsed, probably during a failed attempt to move the building. The incident apparently occurred about 1920.

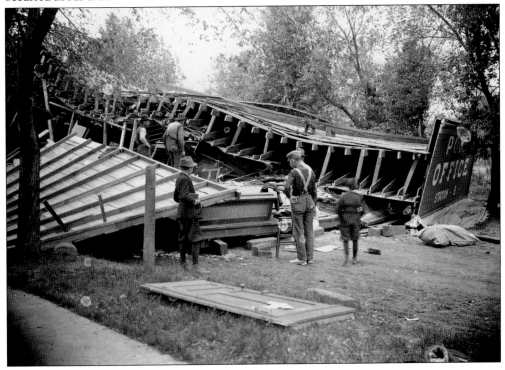

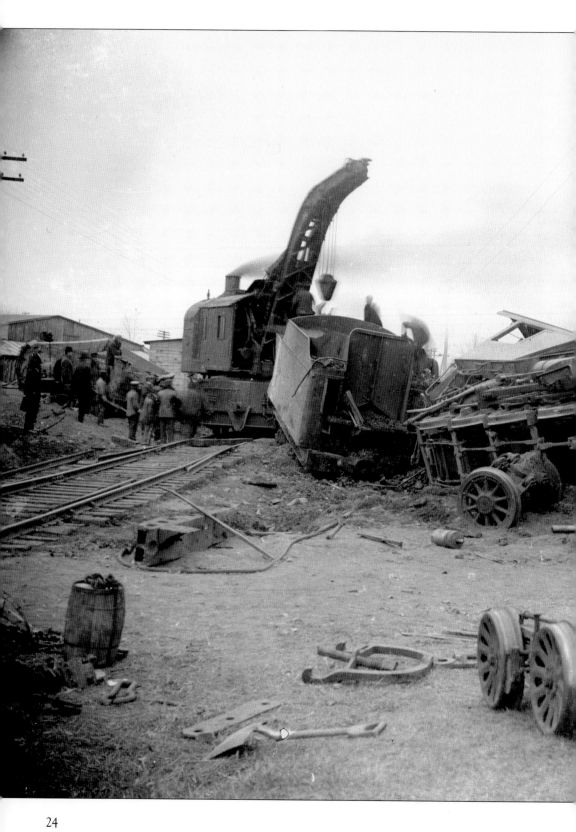

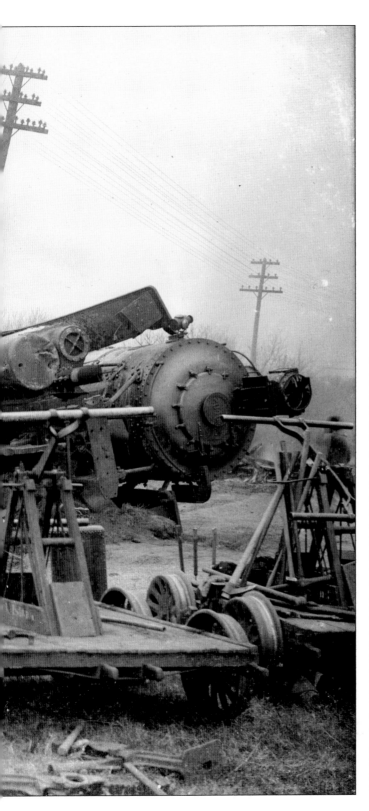

WRECK OF LOCOMOTIVE No. 2040. While this scene includes human spectators in the left background, the photographer has positioned the camera so that the two handcars in the right foreground also appear to be observing the fallen steam engine. The derailed and toppled locomotive bears the name plaque 2040 on the front of the engine. One of the derailed cars in the background is painted with the initials CRI&P of the Chicago, Rock Island and Pacific Railroad. A rail-mounted crane is in the process of lifting the tender away from its wrecked locomotive. Rock Island Railroad built its line through Lincoln in 1892, the last of several railroads to add service to Lincoln. Abandoned in the 1970s, the Rock Island right-of-way is now one of several bicycle trails through the city.

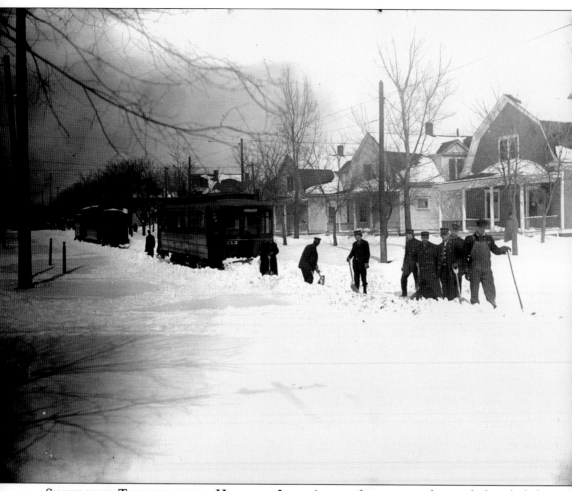

SNOWBOUND TROLLEYS ON THE HAVELOCK LINE. A crew of streetcar workers with shovels, led by a giant man in overalls, clear the way for the Havelock trolley. Havelock was an independent town northeast of Lincoln from 1893 to 1930, built around a large shop facility of the Burlington Railroad. It remains a distinctive neighborhood with a very active Burlington yard.

Two

GATHERED OUTDOORS

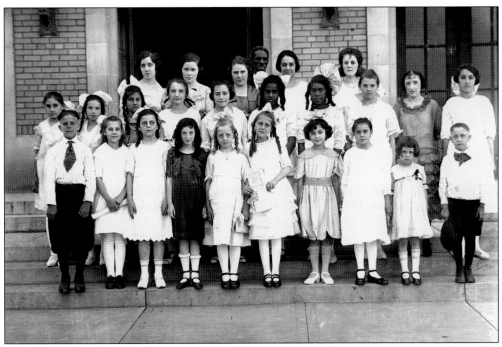

STUDENTS AND TEACHERS AT LINCOLN HIGH SCHOOL. Since he had no studio, John Johnson took most of his photographs in the open air. The students in the front two rows of this group on the steps of Lincoln High School are mixed in age, race, and gender. Lincoln's public schools were integrated, as was the University of Nebraska. The women in the group were presumably teachers; the man in the rear was not. Lincoln Public Schools did not hire an African American teacher until the 1950s. Lincoln's newest elementary school, under construction in 2008, is named for Lt. Col. Paul Adams, a former Tuskegee Airman who taught at Lincoln High School from 1964 to 1982.

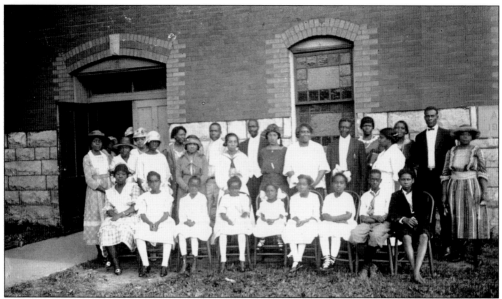

CHURCH GROUP OUTSIDE QUINN CHAPEL, BEFORE 1915. Quinn Chapel African Methodist Episcopal Church was Lincoln's first African American congregation, founded in 1871, just four years after the city was established. The brick and stone church was constructed in 1900 at 1026 F Street. The photograph was taken before the congregation moved the building to Ninth and C Streets in 1915, where the remodeled structure still houses Quinn Chapel in 2008.

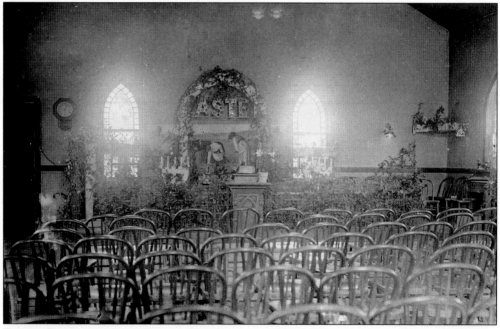

EASTER DECORATIONS IN QUINN CHAPEL, AFTER 1915. John Johnson and his wife, Odessa, were members of Quinn Chapel. Here he photographed the interior of his church after it was moved and remodeled. Note the new Gothic arched windows. The congregation enlarged the church at Ninth and C Streets in 1926. A Johnson photograph of that construction is his last firmly dated view, although he lived until 1953.

FUNERAL FLORAL DISPLAY. A gentleman's portrait is surrounded with flowers and ferns, while the arrangements below the picture memorialize "Our Neighbor." On the right, the flowers bear an inscription "333," associated with the Knights of Tabor, an early African American fraternal group. Lincoln's chapter in the second decade of the 20th century was called Ricketts Commandery No. 14.

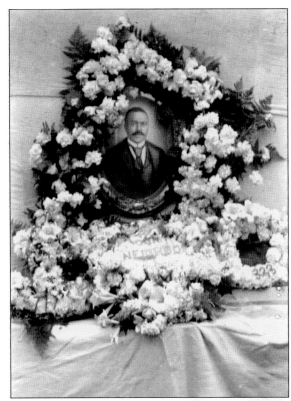

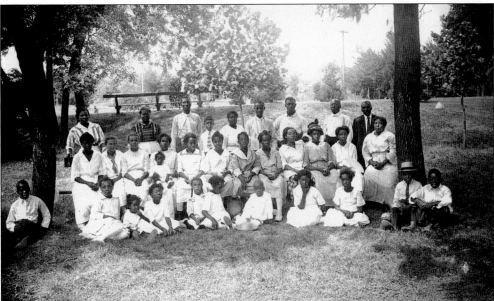

NEWMAN CHURCH GROUP. Newman Methodist Episcopal Church was founded in 1891 as an offshoot of Quinn Chapel. Rev. Albert Talbert (in shirtsleeves, second from right in the back row) was pastor at the time this view was taken, around 1915. His daughter Ruth (bespectacled, third girl from left in the first row) recalled in 2003 that her father often had John Johnson take photographs of Newman's Sunday school groups in Lincoln's Antelope Park.

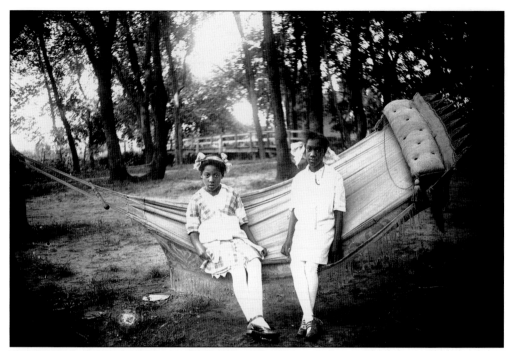

FLORENCE JONES AND FRIEND, 1915–1920. The young lady on the right is Florence Jones (later Clark). Her companion has not been identified. Jones was a student at Park and McKinley Elementary Schools and Lincoln High School, graduating in 1923.

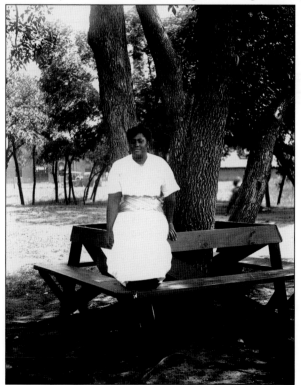

LADY ON A PARK BENCH. Lincoln began to expand its park system in the early 20th century, adding to the single, 10-acre park included in the original plat of 1867. Most of the additional land was acquired along Antelope Creek in the south-central part of the city, combining waterworks and parkland.

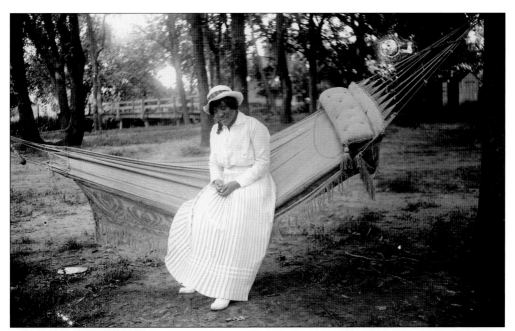

LADY ON A HAMMOCK. A tasseled hammock with built-in pillow provides a perch for this lady to display her elaborately pleated skirt. The footbridge in the background suggests this scene may be Epworth Park, a Methodist-affiliated park and revival ground south of Lincoln on Salt Creek.

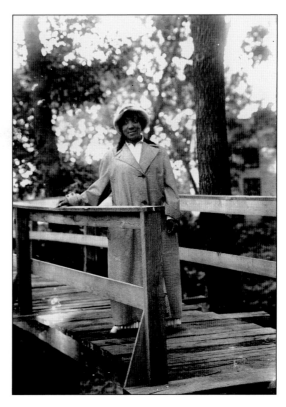

LADY ON A FOOTBRIDGE. How does a lady protect her beautiful pleated skirt on a summer visit to the park? With a houndstooth duster—a lightweight summer overcoat. If the scene is Epworth Park, she probably reached it after a long trolley ride. Clothing and settings often identify multiple photographs that John Johnson took on one day, as on this page and the top of the preceding page.

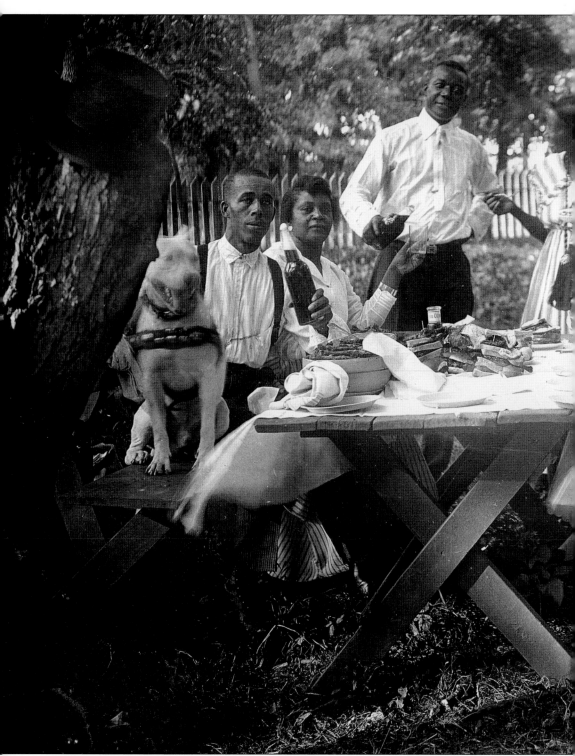

BACKYARD PICNIC. In a backyard enclosed with a picket fence, 10 picnickers (and one pit bull terrier) pause for a toast before their meal. The scene appears casual, but the picnic benches have

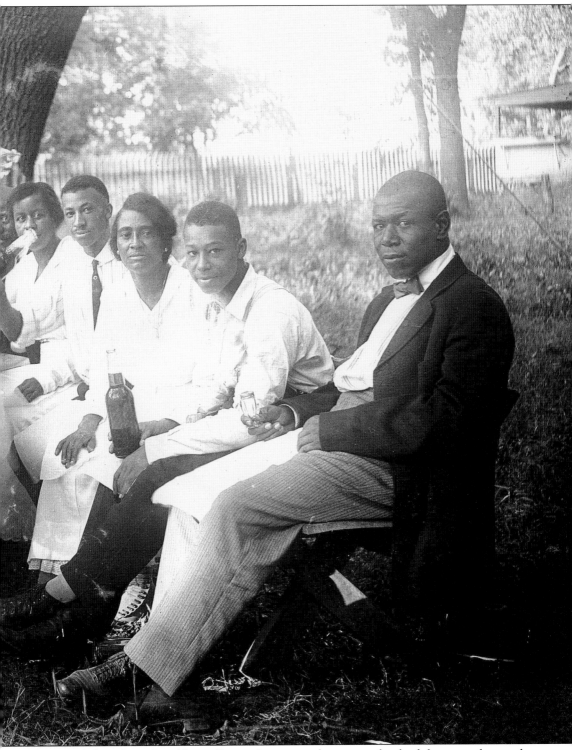

been angled out from the table to allow each person to be seen, and to lead the eye to the couple serving as host and hostess.

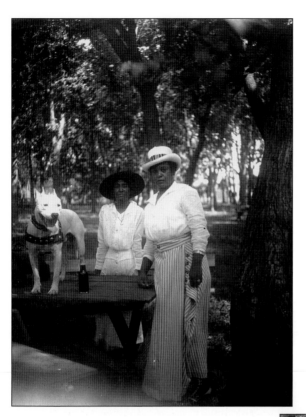

PAMPERED PIT BULL. Two of the picnicking women from pages 32 and 33 show off their hats and the pit bull terrier. The breed may have been popular in Lincoln—a very similar white dog appears on page 44 with a different woman.

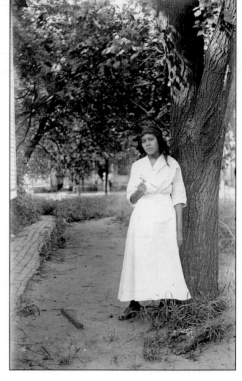

YOUNG WOMAN WITH FLOWER. In a worn and weedy yard, a pretty young woman holds a small flower. John Johnson often posed women beside a tree trunk, perhaps to highlight their white dresses against the dark color and rough texture of the bark.

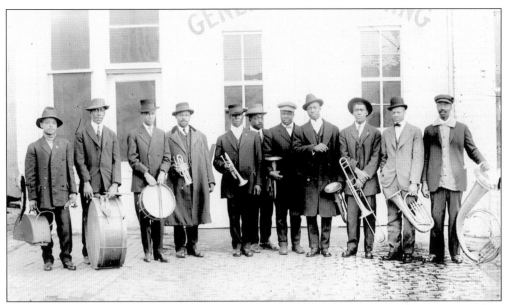

BRASS BAND. Ten instruments for 11 men—the fellow peeking out at the center, standing behind two trumpeters, may have been the group's manager. There were at least two African American bands in early Lincoln. While there is no luggage in this scene, the band appears dressed for travel, and the brick pavement and warehouse-type building suggest they are in a railroad district.

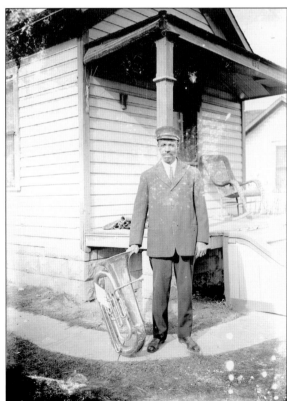

MUSICIAN BESIDE THE SHIPMAN HOUSE. The identity of the musician is uncertain, but his location is revealed by the address 851, which corresponds with the home of Edward and Clara Shipman at 851 University Avenue, located north of Vine Street between North Twelfth and Thirteenth Streets. The house is shown again on pages 46 and 47.

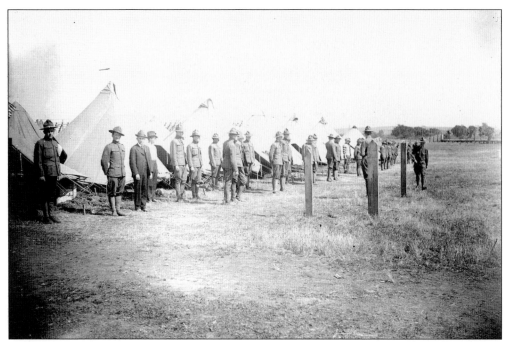

ENCAMPMENT AT THE FAIRGROUNDS. The bleachers, visible between the tents in the image above, and the grandstand backdrop of the photograph below indicate that this military encampment took place at the Nebraska State Fairgrounds in Lincoln. While this sounds like safe duty, hundreds of Lincoln men and several women enlisted in the military during the Great War and dozens died, including two women nurses. A local Red Cross chapter of African American women rolled bandages for wounded soldiers. Several men of the community enlisted, including Dakota Talbert (pages 70, 71, and 116). Two black soldiers from Lincoln, Horace Colley and Clinton Ross, were commissioned as lieutenants.

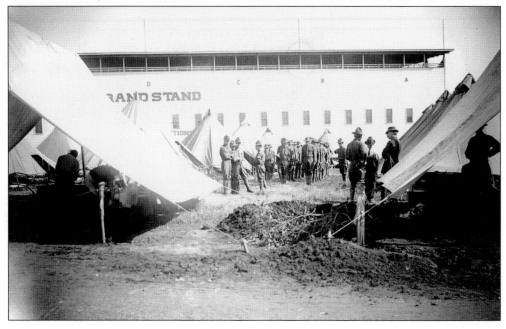

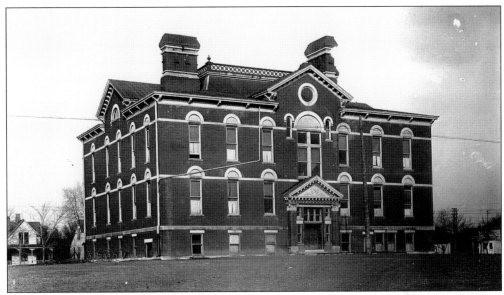

FOOTBALL TEAM AT EVERETT ELEMENTARY SCHOOL. Everett Elementary School was built in 1887 at Eleventh and C Streets. Harrison Johnson built his house two blocks away in 1891 and presumably his son, John, attended school here. The football team John Johnson photographed at the schoolhouse door proudly displays its Everett pennant. Although mixed in age, size, race, and equipment, another damaged negative shows the group lined up in football formation. One youth's striped-sleeve jersey resembles the uniform of the University of Nebraska team in that era. The African American man standing to the left of the pennant may be Pendleton Murray, who graduated from Lincoln High School in 1917 and worked as a carpet cleaner and later as a turnkey at the county jail. Everett Junior High School replaced this school in 1928, then was converted back into an elementary facility in 1990.

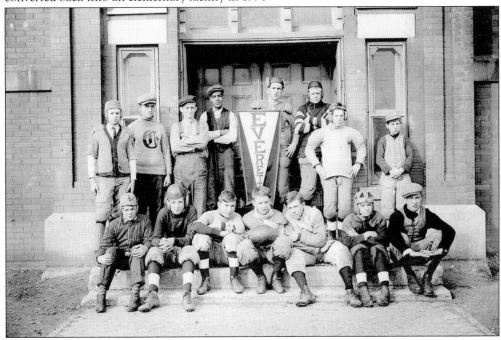

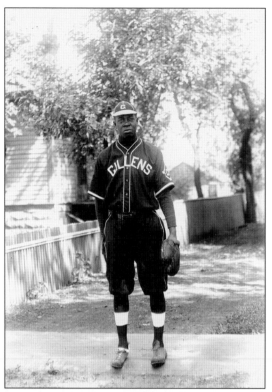

BASEBALL PLAYER. From his socks and knickers to his cap, this ballplayer is well uniformed from head to ankle, but his spiked shoes have seen better days. Frank Gillen, president of Gillen and Boney Candy Company of Lincoln, probably sponsored the team. Around 1890, the all-black Lincoln Giants team met with considerable success against town teams across the state. This player's heavily padded mitt indicates he was a catcher.

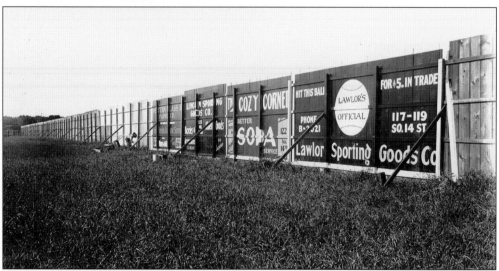

PAINTING THE OUTFIELD FENCE AT LANDIS FIELD, C. 1922. Even Tom Sawyer might not have persuaded anyone to help paint this fence. The businesses advertised on the fence—two sporting goods stores and Cozy Corner soda shop—were founded or relocated to the listed addresses in the early 1920s. Buck Beltzer built Landis Field in 1922 at Second and P Streets, west across the viaduct from downtown Lincoln. It was home to a charter franchise of the Class D Nebraska State League, the Lincoln Links, which returned organized baseball to Lincoln after a five-year hiatus. Beltzer named his field for Kenesaw Mountain Landis, the first commissioner of Major League Baseball. It was home to Nebraska State League and Western League teams until 1939.

Three

PEOPLE, PORCHES, AND PETS

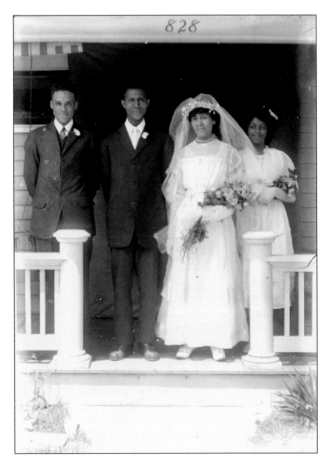

ALLEN WEDDING PARTY. Luther and Ida Allen are pictured at 828 B Street on their wedding day (around 1912). Luther Allen (1885–1969) was prominent in Lincoln's Prince Hall Masons. He was among black leaders from Omaha and Lincoln who met with Gov. Arthur Weaver in 1929 to quell tensions after a severe racial incident in North Platte. Luther was a longtime chauffeur for H. E. Gooch, who published the *Lincoln Star* newspaper and founded Gooch Mills. Ida Allen (1887–1983) was the daughter of Rev. George Maston, with whom they shared 828 B Street. She worked as a maid at the Miller and Paine store. When photographer John Johnson died in 1953, Ida Allen helped distribute his photographs among the families portrayed.

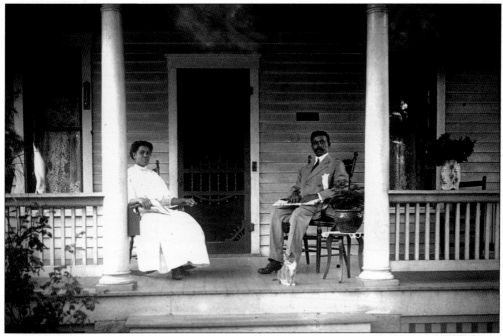

SUMMER PORCH SCENE. This idyllic porch scene, complete with potted plants and a kitten, has a partially visible address plate about the gentleman's head. If this number is 1531, then the couple may be John C. and Mabel Galbreath, who lived for several years at 1531 South Eighteenth Street. He was a waiter at Lincoln Hotel with Ira B. Colley in 1915; in 1920 and 1921, they partnered in a restaurant at 240 North Tenth Street.

THE SHELBY HOUSE, 924 PLUM STREET. James Shelby (1874–1930) and his wife, Mary, stand at the front of the house they purchased in 1912 for a hard-earned $1,800. He worked as a hotel porter, waiter, and eventually headwaiter. She was a dressmaker and a Sunday school teacher at Quinn Chapel. In the early 1920s, James was proprietor of a downtown restaurant. Later in the decade he owned Union Hat Company, offering shoe shining and hat blocking.

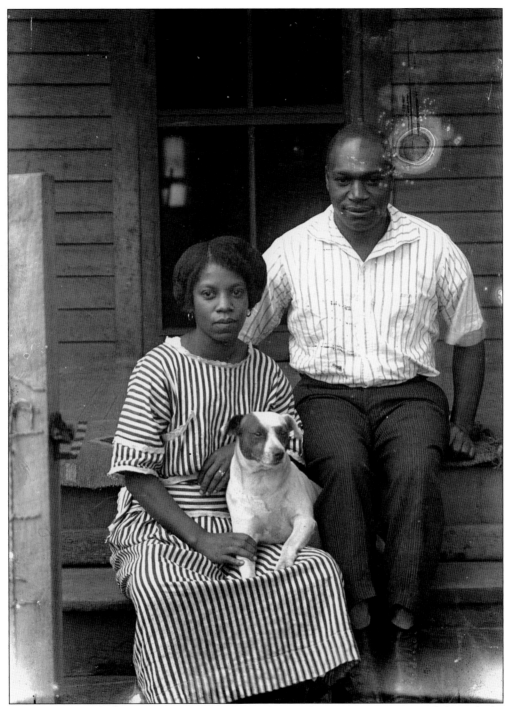

ON THE FRONT STEPS. The fence post at left indicates this portrait was snapped through the open gateway of a shallow front yard. The identity of the young couple has not been discovered, but their comfortable closeness and her casual display of a ring on her left hand suggests they are married. The family dog does not appear to be an entirely willing participant, but the couple is cooperating in gentle restraint.

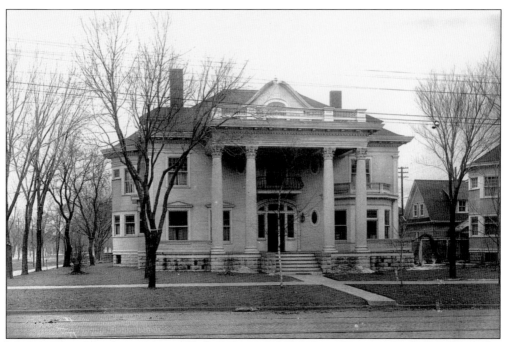

MORRIS WEIL MANSION. Morris Weil was an immigrant from France, a bank founder, and a leading supporter of his synagogue. He built this neoclassical house in 1902 at Seventeenth and C Streets. A Lincoln millwork company proudly advertised that it supplied the porch with its colossal Corinthian columns. The house is now a bed-and-breakfast.

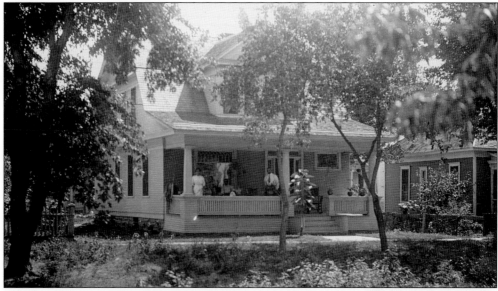

JAMES AND SUSAN O'DONNELL HOUSE. The O'Donnells lived at 623 C Street, in the heart of Lincoln's South Bottoms neighborhood. Immigrant Germans from Russia were the predominant ethnic group in the neighborhood, but the O'Donnells and a number of other African American families resided throughout the area. South Bottoms featured five German churches along with Quinn Chapel African Methodist Episcopal Church at Ninth and C Streets. For many years, James O'Donnell (1872–1930) was the proprietor of a lunch counter in downtown Lincoln.

WINDOW WASHERS. Both of these images feature window washers at work on tall houses. Lettering added to the negatives hints that they may have been intended as trade cards or advertisements for a window-washing service. Although many of the letters have fallen off, the top image includes the address 1616 North Twenty-seventh Street. That is not the house depicted, but instead was the residence in 1915 of Mathew Carter, an African American janitor and John Johnson's probable client for these pictures. The image below is 1634 B Street, a house built in 1908, one block from the Weil house.

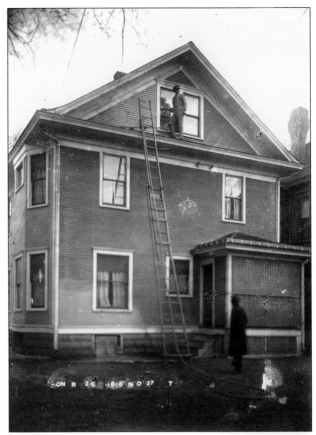

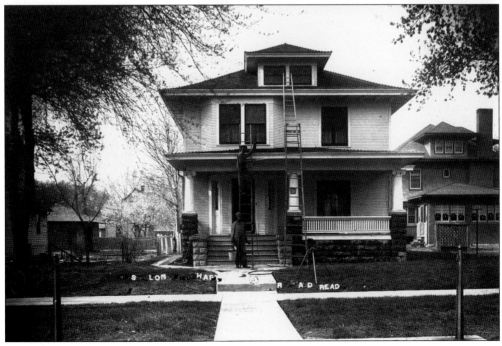

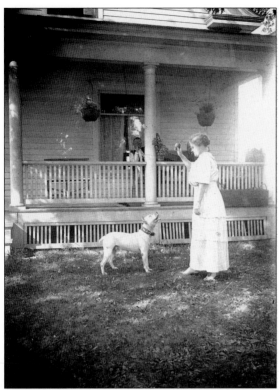

PLAYING FETCH. A white pit bull terrier waits attentively for his lady to throw his ball. The dog looks similar to the pet on pages 32 and 33, but in this image the pet's people are white. The man of the house, partially hidden by the porch column, is looking over the scene from the porch swing, smoking his cigar.

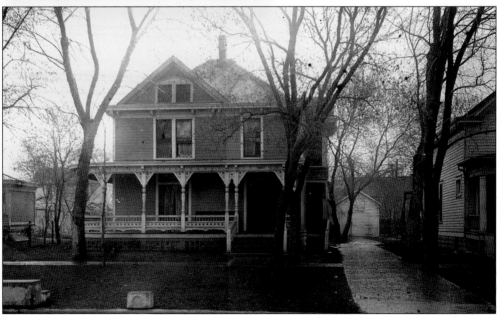

JAMES JUDGE HOUSE, 1210 D STREET. Built around 1882, this Queen Anne–style house with Eastlake detailing was owned by the Judge family from 1910 to 1938. James Judge was a letter carrier and later a postal clerk. John Johnson was a janitor at the post office for many years and took dozens of photographs in and around the post office and courthouse. Judge's house was about four blocks from Johnson's.

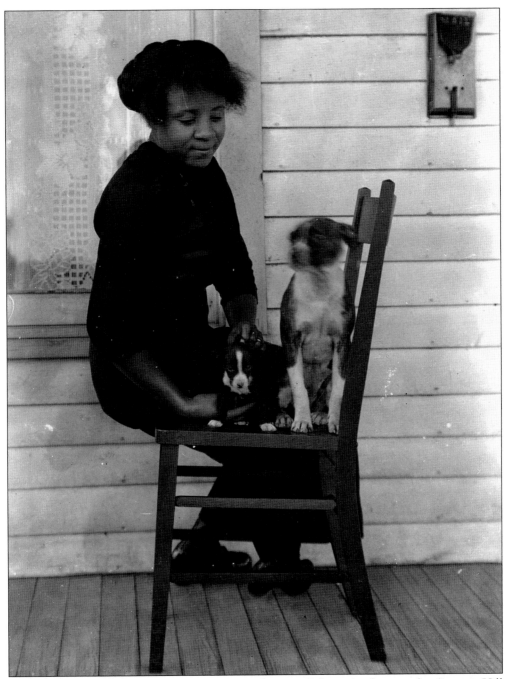

FRANCES HILL WITH PUPPIES. A frequent subject in Johnson's photographs, Frances Hill (1904–1932) graduated from Lincoln High School in 1924. She was listed in the city directories even before graduation, implying that she supported herself, first as an usher at Rialto Theater, then later as a stock girl for Rudge and Guenzel department store. Ruth Folley (page 70) remembered Hill eight decades later as a dear friend in high school. She married Bert Taylor around 1930 and moved to New York City, where she died just two years later at age 28. (See also pages 85, 119, and 120.)

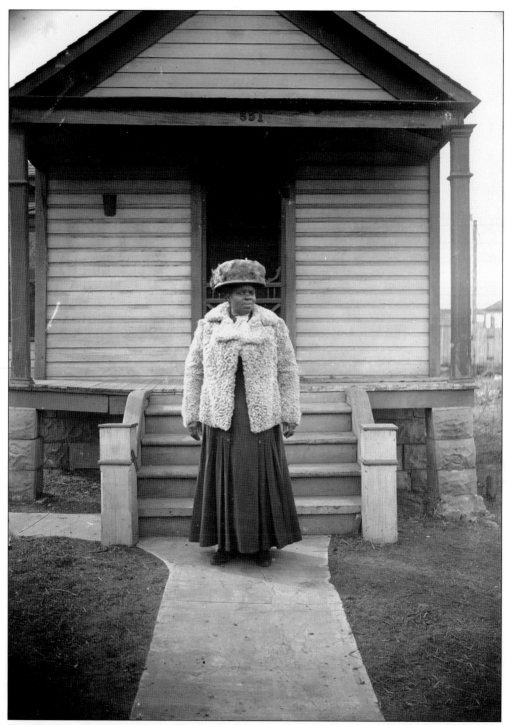

FUR FINERY. This woman is standing in front of the Shipman house at 851 University Avenue, proudly displaying her sheepskin jacket. Clara Shipman (1868–1919) was born in West Virginia. Edward Shipman (1863–1921) worked as a porter and stock man at various Lincoln paint companies.

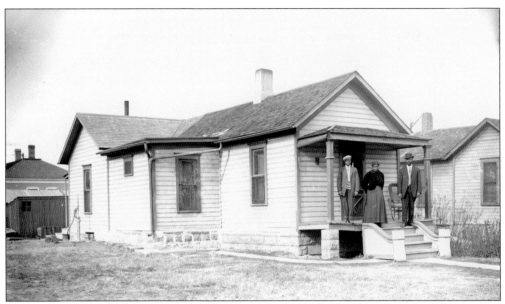

SHIPMAN HOUSE ON THE NORTH SIDE. Prior to the 1920s, a compact neighborhood of small houses was nestled between the growing University of Nebraska campus and the North Bottoms, another enclave of Germans from Russia. Many of the North Side residents were African American, including the Shipman family. Their house was on University Avenue, which ran north from Vine Street between North Twelfth and Thirteenth Streets. In the 1920s, the University of Nebraska built the Coliseum on this location.

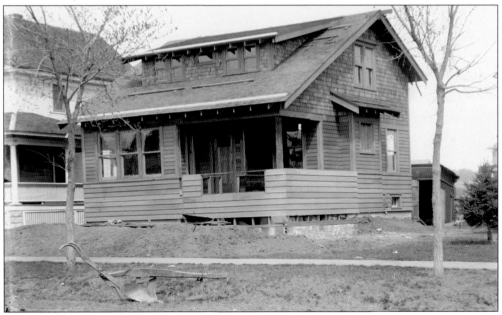

A NEW BUNGALOW. This craftsman-style bungalow appears to be nearing completion, but unfortunately the address has not yet been affixed to the house. The era of these photographs, roughly 1910 to 1925, coincides with the introduction of bungalows among Lincoln house types and their time of greatest popularity. The plow in front of the house probably was used at the construction site to break the soil before the basement was scooped with a horse-drawn drag.

47

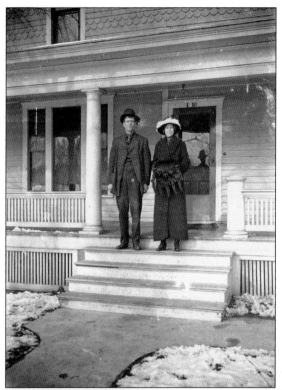

WINTER POSING. This young couple appears ready to step out on a wintry day. Presumably they found their way back home, despite the fact their address had lost one digit. That address could match numerous houses in Lincoln and the location has not been identified. The full-height Tuscan porch column and the cut shingles decorating the upper wall indicate a house that was built at the dawn of the 20th century.

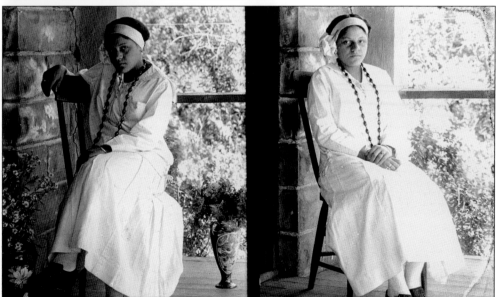

DOUBLE PORTRAIT. Clearly John Johnson had access to the kind of negative holder that exposed two separate images on a single glass plate, but his surviving negatives suggest he seldom used it. Here he captured two effective portraits of a young woman on the porch of a concrete-block house. She is probably Dorothy Loving, who married Clayton Lewis (1903–1967) around 1924 (see page 76). They were both Lincoln High School graduates, and she was an active member of Quinn Chapel.

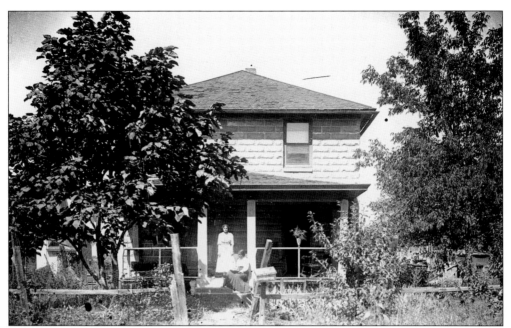

CONCRETE-BLOCK HOUSE. Concrete blocks molded to resemble quarry-faced limestone became the material of choice for house foundations in early-20th-century Lincoln, supplanting limestone. Relatively few whole houses were built of the new material, however. This house may be one still standing at 3310 P Street, where Albert and Devanna Wilson lived in the second decade of the 20th century.

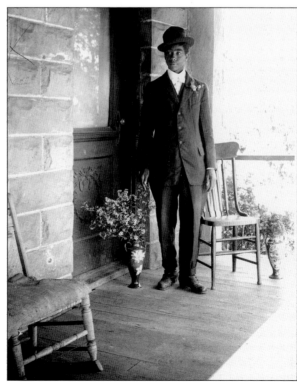

YOUNG MAN WITH FLOWERS.
This young man has flowers pinned to his lapel, as well as in a vase at his feet. The same porch and vase are seen in the two preceding images, but this gentleman's identity is unknown. He is not Dorothy Loving's husband Clayton Lewis (see page 76).

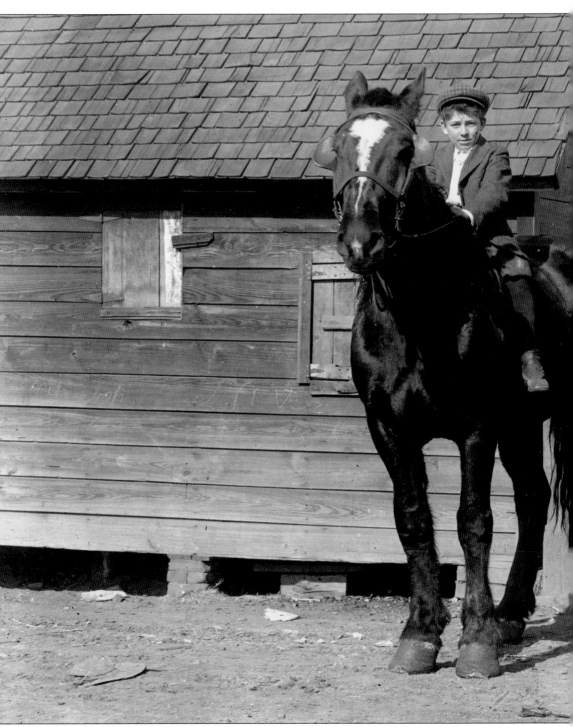

Two Tall Percherons. In a dirt alley behind a small frame house, a man proudly displays a pair of gleaming Percheron draft horses. The boy comfortably seated bareback atop one of them is probably his son. It looks like these big horses could barely fit into the tiny barn behind them. Many Lincoln houses retained carriage houses well into the 20th century, and backyards

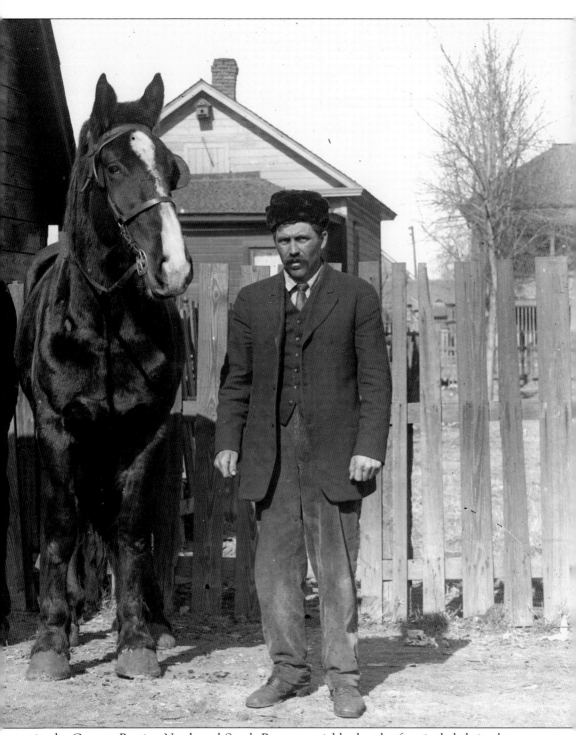

in the German-Russian North and South Bottoms neighborhoods often included tiny barns, chicken coops, and summer kitchens. Importing draft stallions from Europe was a major business in Lincoln in this era, before trucks and tractors became the primary source of horsepower on farms.

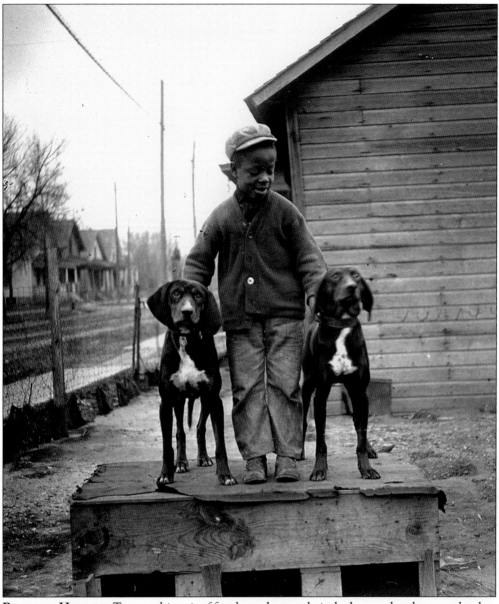

BOY WITH HOUNDS. To pose this pair of fine hounds atop their doghouse, the photographer has enlisted the help of a boy in a crooked-buttoned cardigan sweater.

BABY AND DOG. Many of John Johnson's family portraits include pets. This well-dressed baby in a tall wooden high chair is posed in front of Johnson's familiar backdrop, tacked against a porch wall. The dog is positioned to catch scraps, but from the baby's jacket, it seems likely the day is chilly and dinner will be served inside.

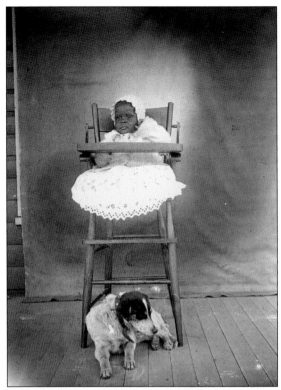

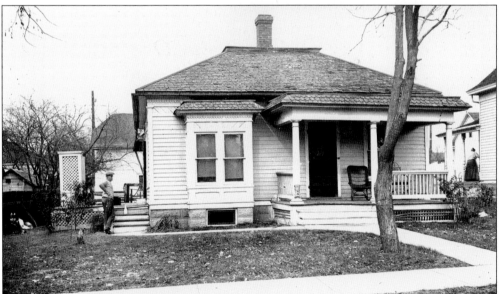

JOHNSON HOUSE, 1310 A STREET. James Trusty, a carpenter and African American Civil War veteran, built this house in 1891 for Harrison Johnson (1849–1900). During the Civil War, Johnson, an Arkansas native, escaped from slavery and took refuge with Nebraska's 1st Regiment. He enlisted as a private and served out the war with the all-white regiment. After the war he settled in Lincoln. He was a member of the Farragut Post of the Grand Army of the Republic and worked as a hotel cook and janitor. Harrison and his wife, Margaret, had one son, John.

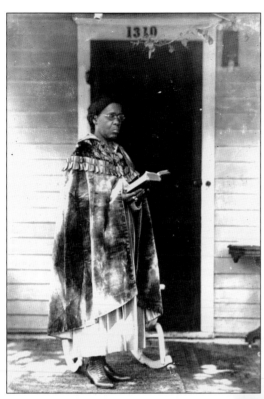

MOTHER MARGARET JOHNSON.
Margaret Johnson was born in Mississippi
in 1854, probably in slavery, and died
in Lincoln in 1926. After her husband,
Harrison, died in 1900, she lived with
her son, John (1879–1953). His wife,
Odessa, joined the household upon their
marriage in 1918. Ruth Folley remembered
Margaret as a small, prim woman who
rode to church ramrod-straight in John's
horse-drawn wagon.

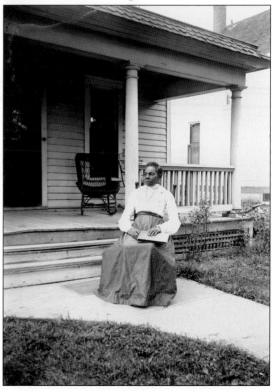

ODESSA JOHNSON AT 1310 A STREET, 1918. Widow Odessa Price (1891–1953) of Kansas City, Kansas, married John Johnson of Lincoln on August 20, 1918. Here Odessa sits on the porch swing of the Johnson home in Lincoln. The elegant white dress and high-heeled white shoes may be her wedding ensemble, as she is perusing the *Ladies Home Journal* from the same month as her wedding. She worked at Lincoln's Hardy Furniture Company for 30 years.

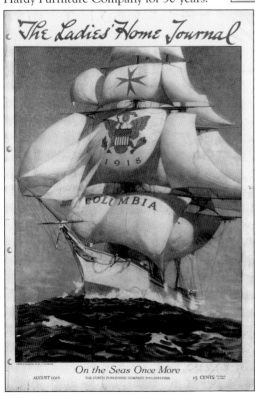

55

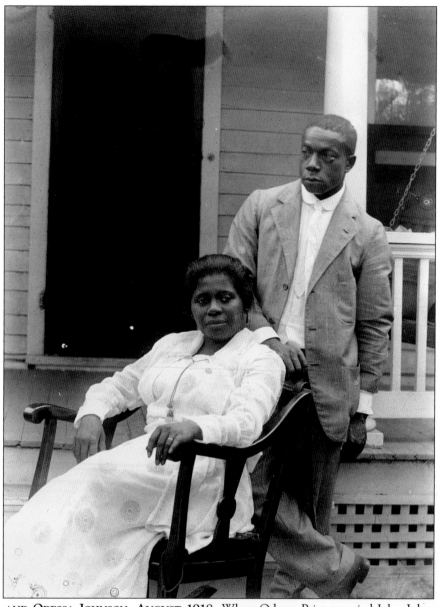

JOHN AND ODESSA JOHNSON, AUGUST 1918. When Odessa Price married John Johnson in 1918, she was 27 and he was 39. This is probably their wedding portrait. The Johnsons were married for 34 years and died within months of each other in 1953. John Johnson must have had assistance in triggering the shutter of his bulky view camera, but his own portrait shows the same combination of careful composition and relaxed subjects seen throughout his photographs. John graduated from Lincoln High School in 1899, where he was a member of the track team. He briefly attended the University of Nebraska, where he played football. He was a laborer and janitor at the U.S. post office and courthouse from 1904 to 1917, and again through the 1930s, but also worked as a drayman and a teamster. John compiled an extensive listing of the African American residents of Lincoln and their occupations for Negro History Week in 1938, mentioning five individuals who worked at portrait studios as photographer's assistants. Under the heading photographer, he listed only "John Johnson."

Four

FAMILIES AND FRIENDS

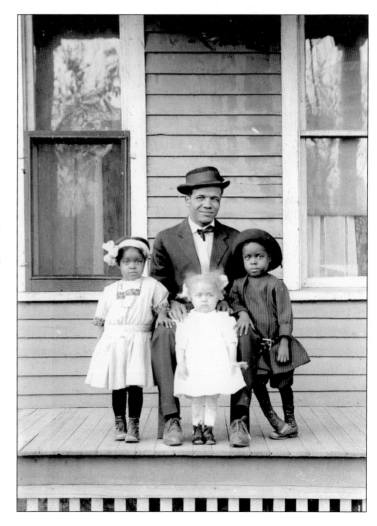

MANITOBA JAMES AND HIS CHILDREN. Manitoba "Toby" James had three daughters and two sons. Pictured with him are his firstborn son Mauranee in the hat at right and his daughters Myrtha (left) and Edna. James worked as a waiter and porter in the 1900s, then as a cleaner at various Lincoln laundries in the second and third decades of the 20th century. He died in Oakland, California, in 1951. Myrtha James married Ben Nelson of Lincoln, to whom John Johnson willed the bulk of his estate upon his death in 1953.

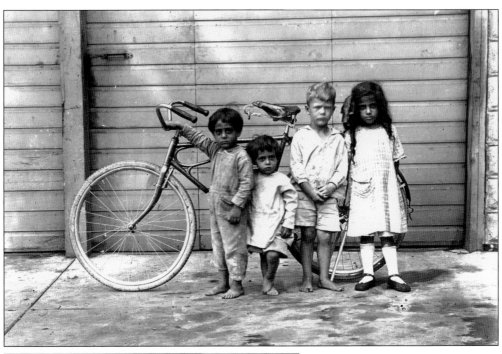

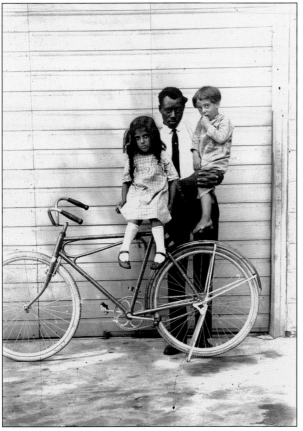

ZAKEM CHILDREN AND FRIENDS, c. 1921. Lebanese-born Alexander K. Zakem (1879–1942) and his wife Anise were the parents of the three dark-haired children. James, born in Michigan in 1917, is at left beside little sister Lillian. The blond boy was a playmate. Older sister Adeline, at right, was born in Montreal in 1916. In the photograph at left, Adeline is perched on the bicycle and a young man holds James. Zakem immigrated to America in the 1890s and came to Nebraska around 1900. When his first wife died, he returned to Lebanon, remarried, and came back to Nebraska in 1918–1927, joining relatives who had settled in the area. He operated restaurants in Lincoln and smaller Nebraska communities. James Zakem, a retired electrical engineer in Michigan, shared the family history in 2000 and indicated that the young man in the photograph at left worked in his father's restaurant.

FLORENCE JONES, KIT CARRIGER, AND FRIEND. At left is Florence Jones; at right is probably Elenora "Kit" Carriger (later Evans). The older woman may be Kit's mother, Alice. Kit Carriger (1893–1981) married George Evans (1874–1945) around 1919. They were very active in Newman Methodist Episcopal Church. George was a charter member of Lincoln's black Masonic lodge and worked for many years as a chauffeur and houseman for C. B. Towle, a manufacturer. Widowed for 36 years, Kit cooked for a fraternity.

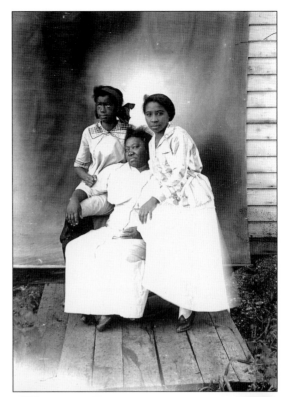

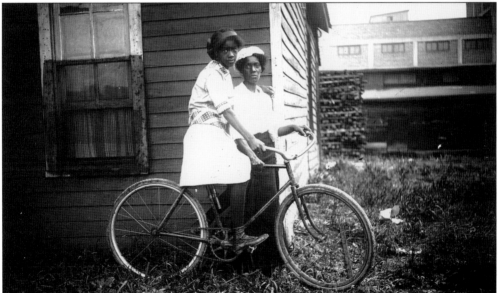

FLORENCE JONES AND HER MOTHER. Florence and her mother, Kate (Constellawaii) Wilson (1883–1962), lived on South Seventh Street, at the edge of an industrial area. The building in the background was the Griswold Seed Company elevator at Eighth and N Streets. Ruth Folley recalled Florence bicycling all over Lincoln. They once rode together to Florence's dish-washing job at a big house on Sheridan Boulevard. Florence graduated from Lincoln High School in 1923.

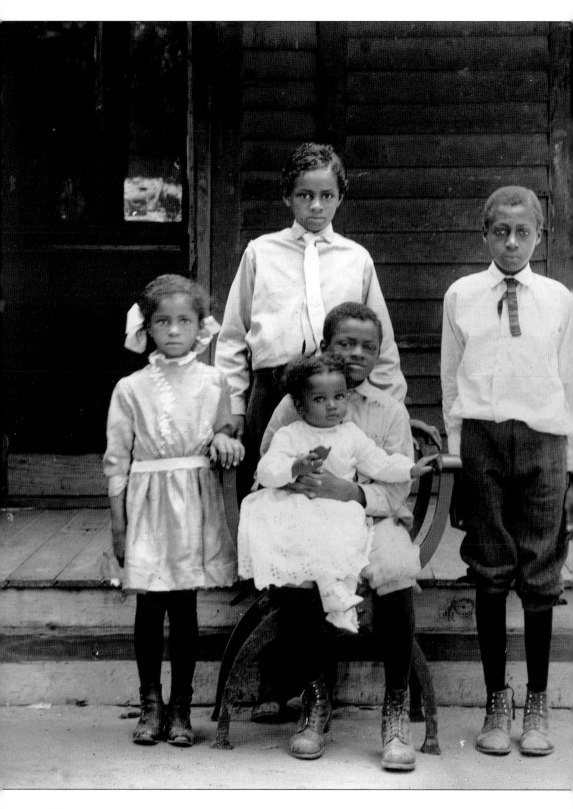

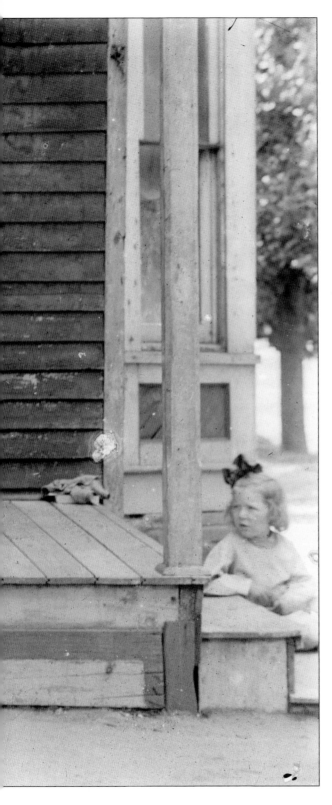

THE THOMAS CHILDREN AND FRIENDS. Cora and Alonzo (Lon) Thomas operated a small grocery from the front room of this house at 715 C Street. Four of their five children are portrayed here. Baby Lonnie, born in 1909, sits on Herschel's lap. Agnes stands at left, and eldest son Wendell stands at the center. The young man at right is probably Lucius Knight, their mother's half brother. Wendell worked a typical variety of jobs in Lincoln—waiter, clerk, porter, laborer, and janitor—before founding the Thomas Funeral Home in Omaha. The Thomas family and many other African American families lived in the South Bottoms, a neighborhood mainly of Germans from Russia, Lincoln's largest immigrant group. The little blonde girl who leans into the right edge of this view serves as a reminder that Lincoln's residential neighborhoods were not segregated by race in the early 20th century—poor people of many ethnicities lived together. A few years later and through the middle third of that century, residential segregation became prevalent in Lincoln. A close-knit black neighborhood arose from that adversity, centered around Twenty-first and T Streets.

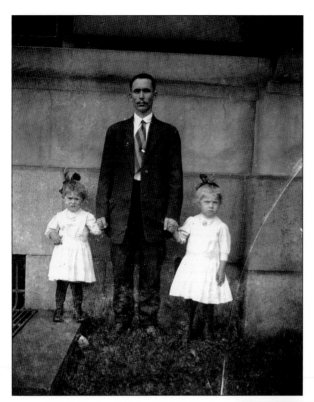

FATHER AND DAUGHTERS. This father and his fair-haired daughters stand beside the massive stonework of the Lincoln post office and courthouse. Perhaps he was a coworker of John Johnson in that building.

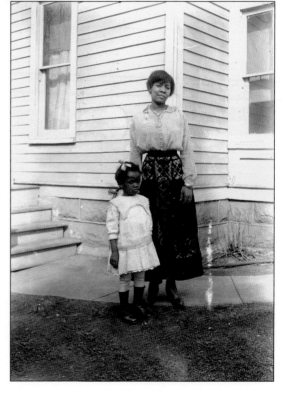

MOTHER AND DAUGHTER. Johnson often traveled throughout the community to take his photographs, but in this case his subjects came to him. This mother in her elegant skirt and the skeptical little girl are standing at the southwest corner of Johnson's house on A Street (see page 53).

FATHER AND BABY. A dapper father holds his baby with pride and confidence.

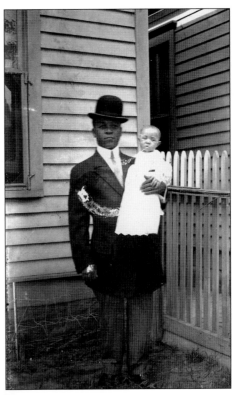

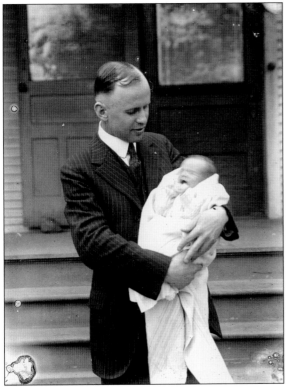

MATCHING HAIRLINES. This father looks appropriately enthralled, while his baby yawns.

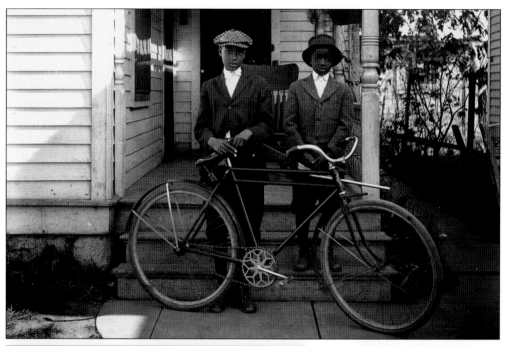

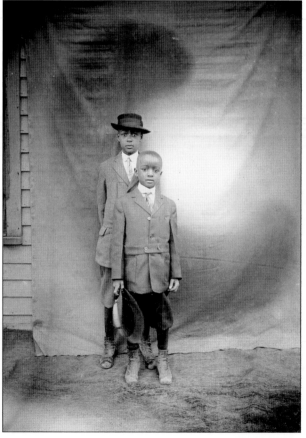

MILLARD AND DELMAR WOODS.
Millard Woods (1904–1966)
and his younger brother Delmar
(1907–1978) were the sons of
William and Elizabeth Woods.
The brothers attended Lincoln
High School, and Millard
continued on to the University
of Nebraska, earning a degree
in pharmacy in 1928, followed
by graduate study in school
administration. He headed the
science department of Paul Quinn
College in Waco, Texas, from
1928 to 1930, then was principal
of the Phoenix (Arizona) Union
Colored High School from 1930
to 1932. He returned to Lincoln
and for a decade was the founding
executive of the Lincoln Urban
League. He served with the Red
Cross in Italy and North Africa
from 1942 to 1945, for which he
received the Medal of Freedom.
He worked in Michigan after the
war. From 1954 to 1966, he held
various posts in welfare services
in Chicago.

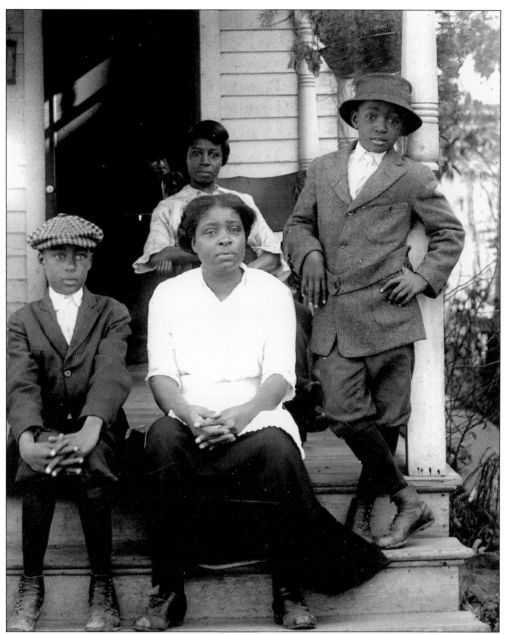

LIZZIE WOODS AND HER SONS. Elizabeth (Lizzie) Woods (1877–1964) sits between her sons Millard (left) and Delmar on their front steps at 650 South Twentieth Street. Her sister Maude Johnson (1880–1963), who lived next door with her husband, Cicero (1869–1941), sits behind them on the porch. Maude and Lizzie's sister Cora Thomas was mother of the children seen on pages 60 and 61. Lizzie's husband, William Woods (1867–1944), was well known as the caretaker of the Nebraska Executive Mansion for 36 years, serving 11 governors. He also worked as a policeman, manager at the country club, and operator of a restaurant at the Nebraska State Fair. He was a leading member of Quinn Chapel and a founder of Lincoln's African American Masonic Lebanon Lodge. His son Millard married Ernesteen; Delmar's wife was Esther. Delmar worked as a laboratory assistant at the University of Nebraska at Omaha.

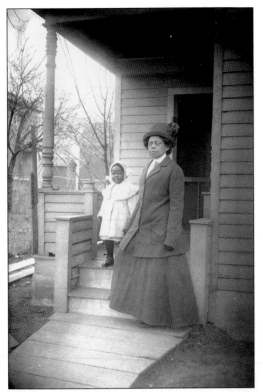

WHOSE PORCH? This modest porch was the setting of many John Johnson photographs of women and children, but none of the images yield a clue to the location or identities. The same youngster in the white winter coat is seen with two sisters on page 93, and the trio appears with another woman on page 68. The various images of the trio suggest this child is younger brother to the two sisters. Is he standing here with one of his grandmothers? The baby carriage with graceful spring suspension would have helped smooth the bumps of dirt streets and boardwalks.

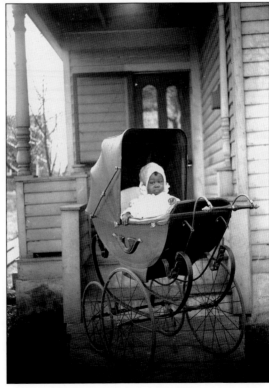

BIEBERSTEIN CHILDREN. Two children, probably brother and sister, stand far apart on the wide front steps of their porch at 1321 South Fourteenth Street, the home of Lillian Bieberstein (1879–1951) and her husband, Paul. The Biebersteins lived just around the corner from John Johnson's home at 1310 A Street, and Paul (1879–1959) operated a saloon less than a block from the Lincoln post office where Johnson worked. When Nebraska prohibited alcohol sales in 1917, two years ahead of the national Prohibition, Bieberstein switched to selling soft drinks, according to the city directory. The second photograph of a little girl standing by the rosebush closely resembles the girl on the steps, but the shoes and sleeves differ. It is unclear whether the portraits were taken on different days or if two sisters posed for the two pictures.

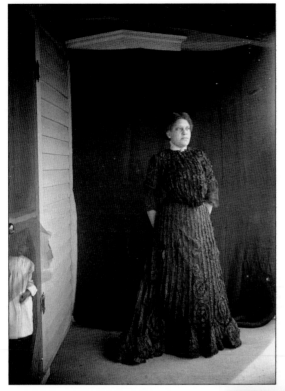

MATRON AND CHILDREN. Hopefully, someday a descendant of this family will view these images and reveal their subjects based on family history and heirloom photographs. Until then, observation and imagination fill the blanks. The middle child peers curiously through the screen door as a grandmother stands alone for her portrait. In the second picture, the three children join her for a group portrait, with their simple white dresses contrasting sharply with her fancy, long black dress and the dark backdrop. The babe-in-arms never has hair ribbons in any of these portraits, identifying him as the little brother.

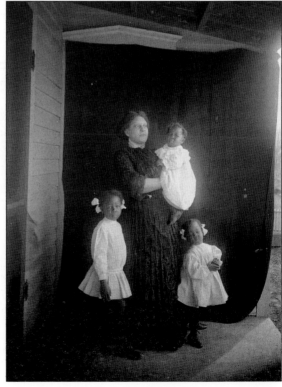

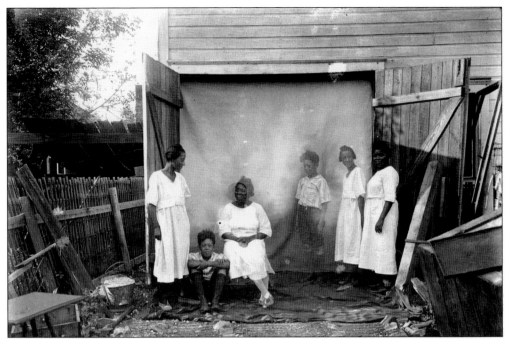

DOUBLE EXPOSURE. John Johnson used the big double doors of an outbuilding—perhaps the frame barn he built in his backyard in 1908—to frame this image in which he experimented with a double exposure. The six figures are three people photographed twice. His wife, Odessa, stands at right and sits in the center of the group.

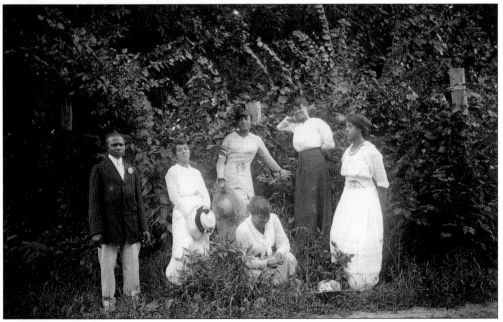

FRIENDS IN A PARK. Even in black and white, this summer photograph glows with greenery. The five young women may be teasing the young man about the flower on his lapel, tucking wildflowers in their hats and waistbands. Whatever their lost story, this is a happy group in a lush setting.

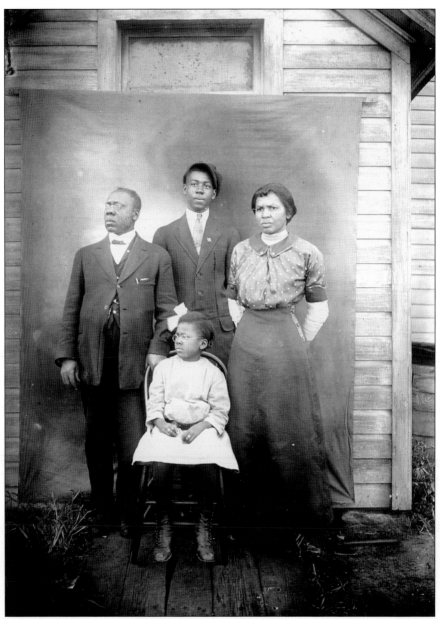

THE TALBERT FAMILY. Rev. Albert W. Talbert (1859–?), his wife Mildred (1874–1960), son Dakota (1898–1968), and daughter Ruth (1906–2005) pose in front of Newman Methodist Episcopal Church at 733 J Street around 1914. The Talberts came to Lincoln in 1914 from Guthrie, Oklahoma, and Reverend Talbert ministered to his African American congregation until 1920. Mother Millie later worked as a hairdresser to support Ruth through Lincoln High School and as she earned a two-year teaching certification at the University of Nebraska in 1926. This image is pivotal in the understanding of this body of photographs, because the negative reached California in the collection of Douglas Keister, while an original print of the family portrait survived in the possession of Ruth Talbert (later Greene, then Folley). She told Abigail Anderson and Edward F. Zimmer in 2002, "Mr. Johnny Johnson took our picture." Her oral history interviews with Anderson greatly enriched Lincoln history and this book.

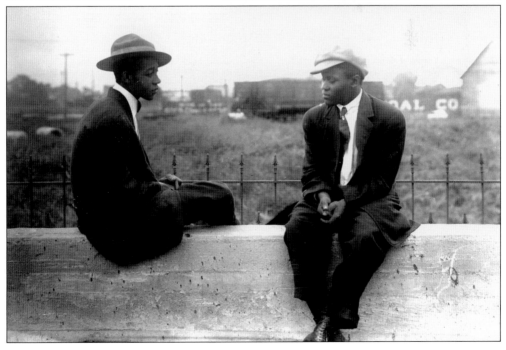

DAKOTA TALBERT AND FRIEND.
Dakota Talbert was born in Fort Scott, Kansas, and came to Lincoln with his family in 1913. He served in the army in France during World War I. His uniform featured a hat very much like this one. The concrete wall may be part of a bridge crossing Antelope Creek at Sixteenth or Seventeenth Street, north of the university campus. His sister identified the young man seated with Talbert as most likely his friend Vernon Howard. Talbert worked as an elevator operator, shoe shiner, driver, and cook in Lincoln and Omaha restaurants.

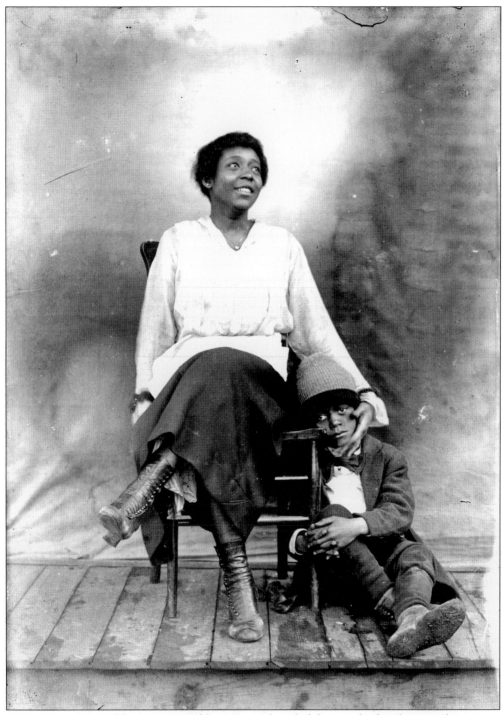

MOTHER AND SON. This woman and boy are unidentified, but surely the photograph captures a mother's reassuring touch.

Five

PORTRAITS

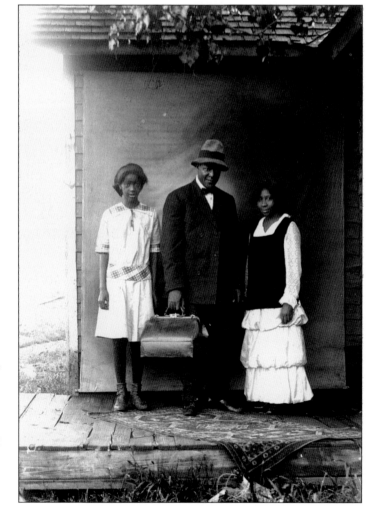

FLORENCE JONES, KIT CARRIGER, AND A GENTLEMAN. The same young women depicted at the top of page 59 here pose before John Johnson's portable backdrop, flanking a gentleman with a black bag. Perhaps he was a traveler, but if the satchel is a medical bag, then the man may have been Dr. Harrison A. Longdon. He was one of two black physicians who served Lincoln's African American community in this era. Longdon was in Lincoln from about 1911 to 1916, overlapping for those years with Dr. Arthur B. Moss, who served from about 1911 until his death in 1938.

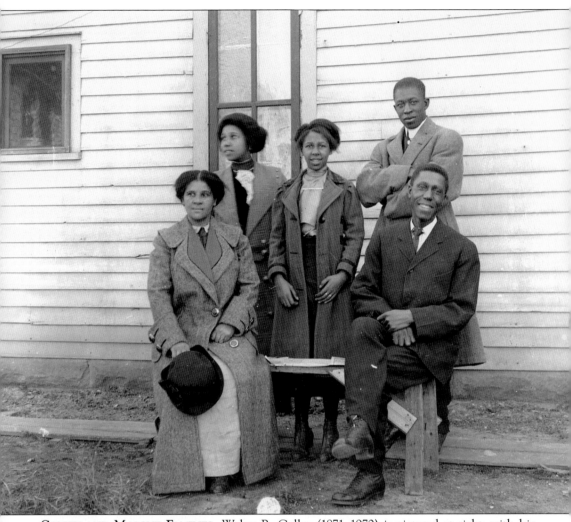

COLLEY AND MALONE FAMILIES. Walter R. Colley (1871–1970) is pictured at right, with his son-in-law Clyde Malone (1890–1951) standing behind him. Colley's wife Lula (1875–1958) shared the bench with her husband; between them stood their daughter Izetta (1892–1966). Clyde was 20 and Izetta 18 when they married in 1910, around the time this photograph was taken. As Clyde Malone wrote in 1946, "After graduation from high school, I was fatally bitten by the matrimonial bug and deluded Miss Izetta Colley, of the Missouri Colleys, into saying 'I do', (and she has for lo' these many years)." Their marriage lasted over 40 years until Clyde's death in 1951. Clyde Malone, standing at right, was born in Lincoln to Frank and Pency Malone. His father was a plasterer. Beside him is his wife, Izetta, whose parents, Lulu and Walter Colley, moved their family from Lexington, Missouri, to Lincoln in 1905. Father and son-in-law held service jobs typical of those available to black men in Lincoln in the first two decades of the 20th century—porter, janitor, waiter—before partnering to operate a grocery store in 1920–1921. Clyde then attended the University of Nebraska and graduated in 1925. Clyde and Izetta left Lincoln for about a decade while he worked as a district manager for an insurance company and then at a community center in Minneapolis, before returning to work at Lincoln's Urban League. He became executive director in 1943 and served until his sudden death in 1951. The Urban League was renamed Clyde Malone Community Center in his memory. Izetta was director of music at Quinn Chapel and played organ and sang at Lincoln's other black churches.

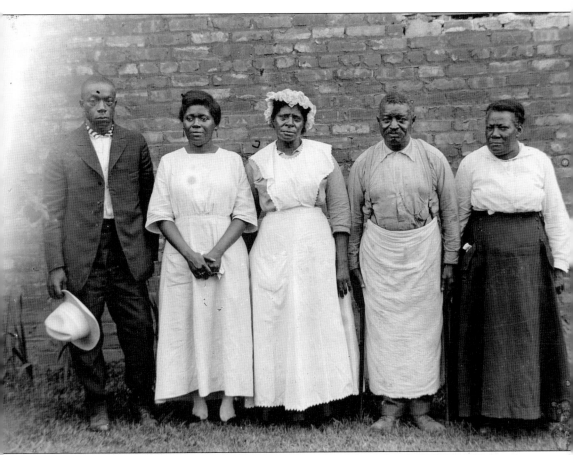

JOHN AND ODESSA JOHNSON AND FRIENDS. Photographer John Johnson doffs his tall white hat for this self-portrait with his wife, Odessa, and three friends in their work clothes. They have posed on grass beside a rough brick wall, adding texture to the image. If Johnson created any business records or other accounts of his photography, they have not been found so one cannot identify who might have assisted him in self-portraits and in handling his bulky equipment. A good candidate is Earl McWilliams (1892–1960), whom Johnson noted as the only young man among the "photographers assistants" in his typescript "Negro History of Lincoln 1888 to 1938." McWilliams was the son of former slaves John and Sarah McWilliams, who settled their large family in Lincoln in the 1880s after homesteading near Falls City, Nebraska. A significant group of Johnson negatives are preserved through the stewardship of McWilliams descendants.

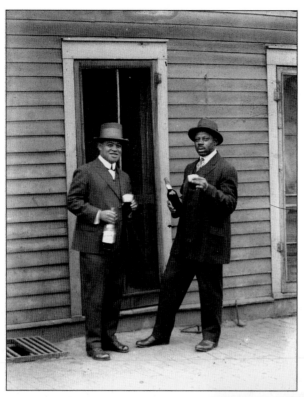

SHARING A DRINK—OR A JOKE?

In one image, two friends appear to toast the viewer with a favorite beverage. In the matching view, the same gentlemen pose with casual dignity. Several series of John Johnson photographs raise questions as to their exact purposes, while some were clearly posed as jokes. The man at left in these views may be Clayton Lewis, a star athlete at Lincoln High School who graduated in 1922 and married Dorothy Loving (see page 48). Clayton (1903–1967) worked as a "red cap" (porter) for the Chicago, Burlington and Quincy Railroad, then for many years was employed by the Lincoln Water Department before moving to Los Angeles in 1960.

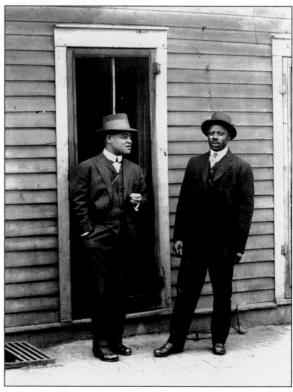

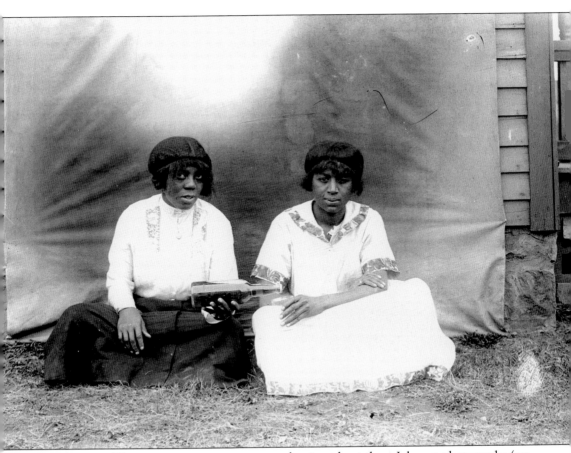

GIRLFRIENDS. These young women appear together in at least three Johnson photographs (see page 84). Like the previous picture, this image is ambiguous—one friend pretends to pour a drink for the other, but the bottle is capped.

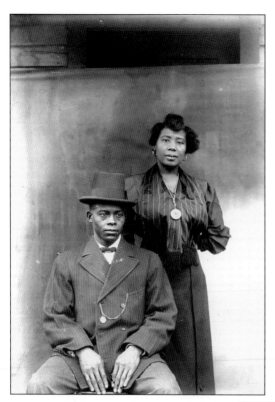

LEON AND BREVY (HILL) LILLIE. Brevy (Hill) Lillie was one of the oldest of several children of P. M. E. and Eliza Hill. P. M. E. Hill gave an oral history to an interviewer with the WPA program of the 1930s, tracing the family ancestry to the Yuruban people of Africa. He celebrated their heritage by giving several of his children African names—sons Pahio and Tazonia and daughters Zanzye and XaCadene. Ruth Folley remembered her Lincoln High School classmate Zanzye as very brilliant. Zanzye Hill went on to earn a law degree from the University of Nebraska in 1929, Nebraska's first African American female graduate in that profession. She served as chief counsel for an Arkansas insurance company before her death in the 1930s. Her younger sister XaCadene became a physician.

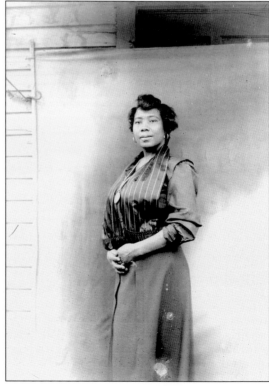

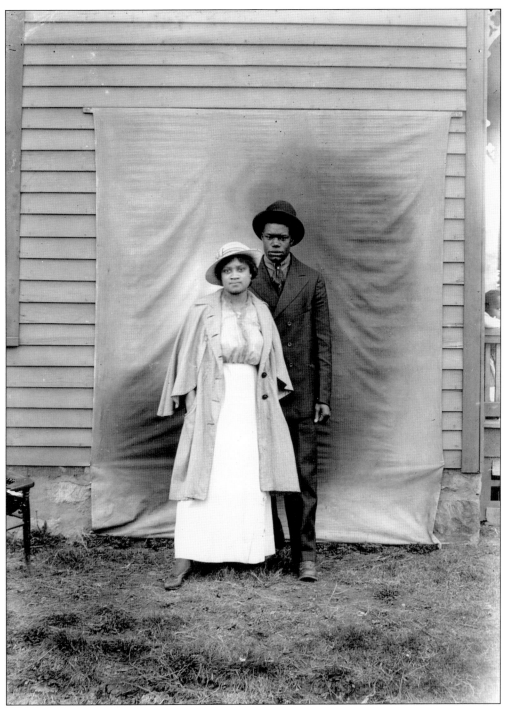

YOUNG COUPLE. The few surviving vintage prints from John Johnson photographs suggest that he might have intended to crop an image like this one, excluding all but the couple and a portion of his backdrop. But the full-frame negative brings the scene to life, showing his backdrop tacked against the side of a clapboard house, with an old chair to the left and a small child observing the activity from the right edge.

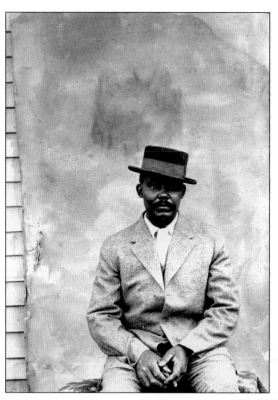

A HUSBAND AND A WIFE.
Photographed separately or together, this couple appears well matched in dress and demeanor.

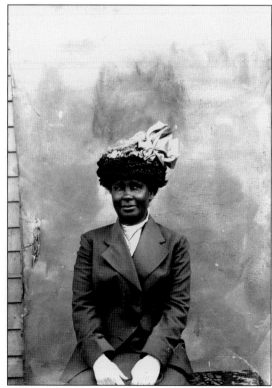

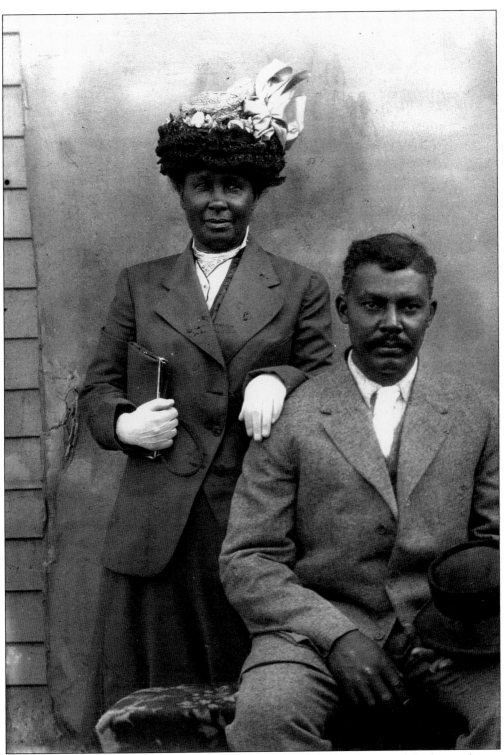

WIFE AND HUSBAND. The lady retains her elaborate hat in both portraits, while the gentleman changes his hat, but not his expression.

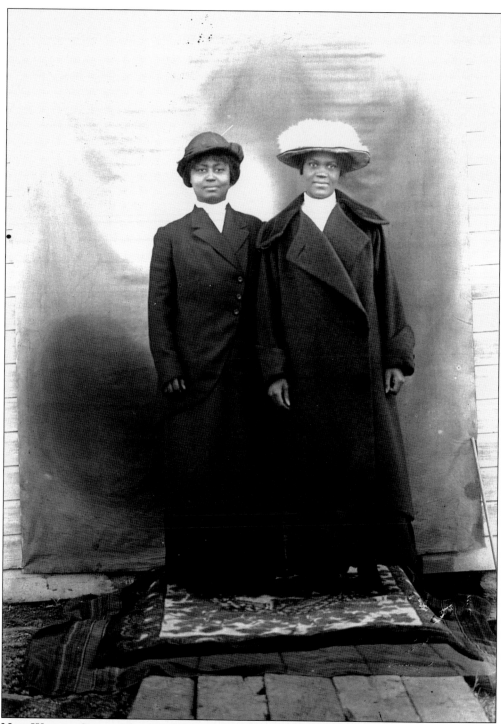

New Winter Coats. The day only appears chilly—these young women are intent on showing off their winter finery. Page 85 depicts the same pair, probably on the same day, looking comfortable in skirts and blouses. Their identities have not been recovered.

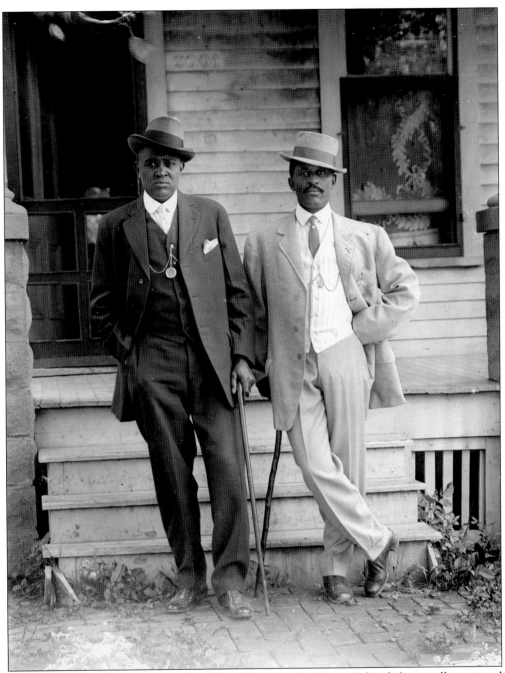

GEORGE W. BUTCHER AND FRIEND. The address on the house behind these well-appointed gentlemen is 2001, corresponding with the home of George and Fronia Butcher at 2001 U Street. George (thought to be the taller man) was born in Philadelphia in 1874, died at the VA hospital in Lincoln in 1958, and is interred in Wyuka Cemetery's Soldiers Circle. He worked for Chicago and Rock Island Railroad as a porter and for Burlington Railroad as a laborer in the Havelock shops. Fronia Butcher was even more long-lived, reaching 100 years of age (1879–1979). George's dapper companion in this portrait remains unidentified.

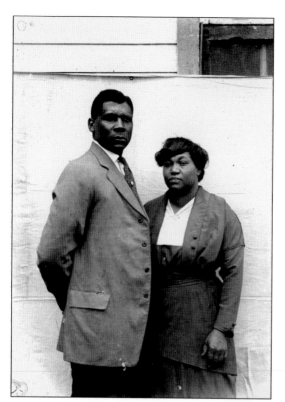

MAN AND WOMAN. John Johnson's best portraits seem to allow his subjects to present themselves, rather than imposing the photographer's view of them. Of course, that seeming transparency is a hallmark of a talented photographer.

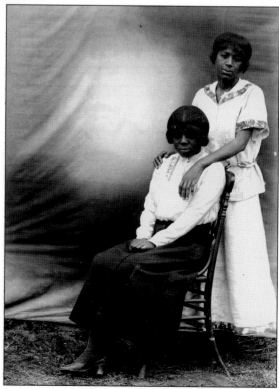

FRIENDS, AGAIN. The young women depicted on page 77 appear here in the same clothing as the other image, but with a more dignified and conventional pose.

FRANCES HILL AND MATRON. Frances Hill (1904–1932) stands demurely behind an older woman—perhaps her mother? Hill boarded with John C. Galbreath's family even before she graduated from Lincoln High School in 1924 and as late as 1929. Galbreath also provided her grave at Wyuka Cemetery upon her young death in 1932. (See also pages 45, 119, and 120.)

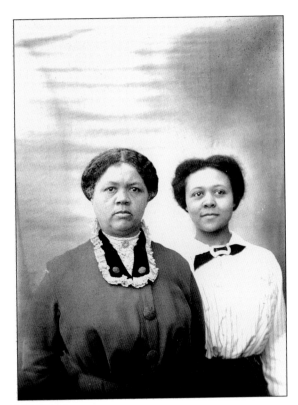

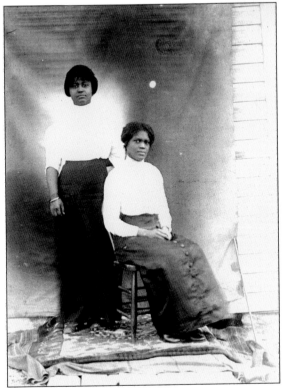

WITHOUT WINTER COATS. A companion image to the dual portrait on page 82, here the friends pose comfortably without their hats and coats. The seated woman appears again in a solo portrait on page 104. Perhaps she is also the young wife on the porch shown on the top of page 40.

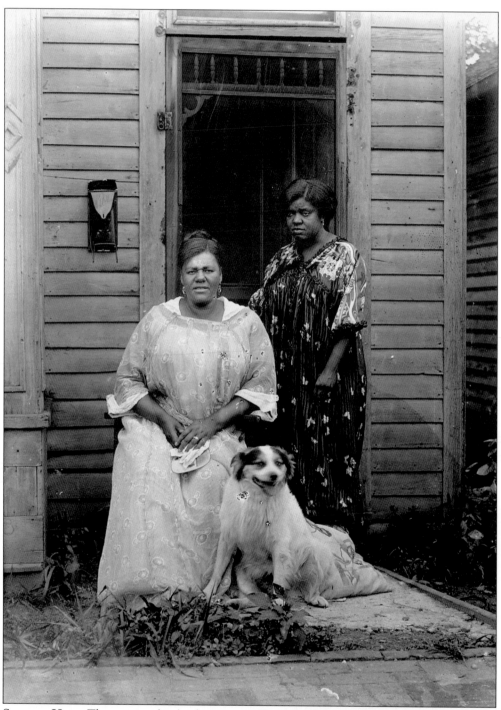

SUMMER HEAT. The panting dog (with its own cushion), hand fan, and kerchief all suggest a hot summer day. The old house probably is in or near to downtown, as it is positioned much closer to the sidewalk than typical of most of Lincoln's residential areas, even of low-income residents.

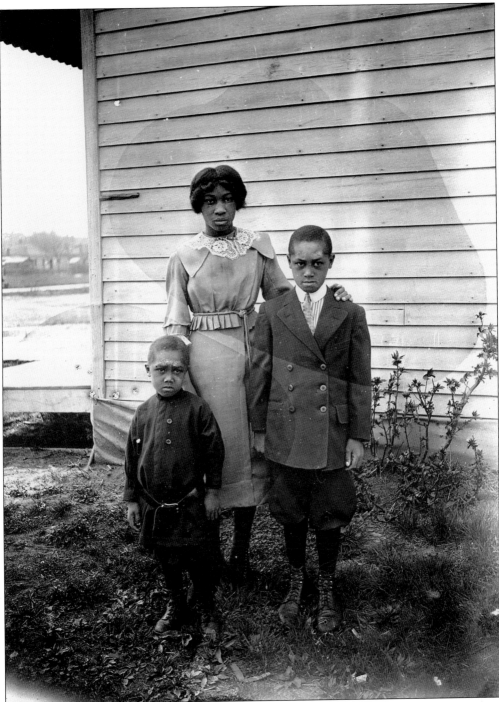

SISTER AND BROTHERS. The two boys, probably brothers, are dressed quite differently, reflecting their ages. The younger fellow wears a long tunic over his knickers, while the older boy has a double-breasted coat, shirt, and tie—plus knickers. The young woman wears a tailored dress, lace collar, and button shoes. There were several seamstresses in Lincoln's African American community.

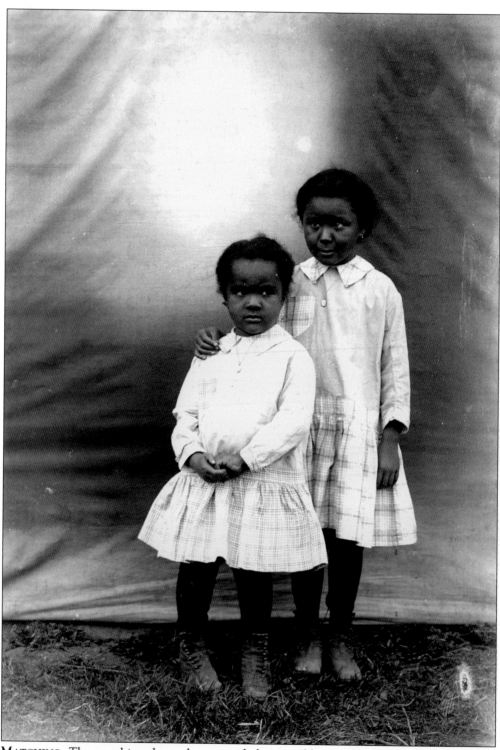

MATCHING. The matching shoes, dresses, and chain necklaces with small medals all suggest that these girls are sisters.

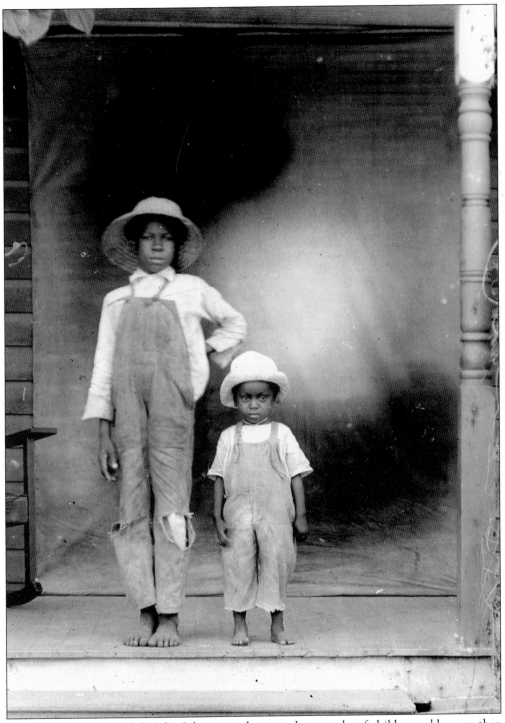

BOYS IN OVERALLS. While John Johnson took many photographs of children, seldom are they wearing clothing that looks suitable for work or play. From their straw hats to bare feet, this pair is ready to step off the porch and into summer.

BROTHER AND YOUNGER SISTER. This boy wears a jacket with elaborately embroidered lapels and a wide belt similar to that of the small boy depicted on page 87.

BESIDE THE CHURCH. The wall behind this young man, who poses so confidently, appears to be Mount Zion Baptist Church. That African American congregation was Lincoln's second black church when founded in 1879. The congregation built a stone "basement church" in 1892 on a building site received from the Nebraska legislature in 1883. The stuccoed main story of the church was not added until 1922–1925.

PAIRS OF SIBLINGS. It appears that John Johnson sometimes set up his open-air "studio" and families brought their children to him. It is difficult to be certain whether these images were taken the same day, but they were taken on the same rug and perhaps used the same chair. Baby boys and girls were often dressed similarly, but hair ribbons were huge and hugely popular for girls only.

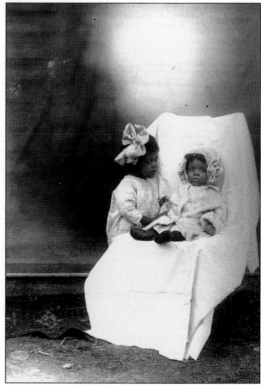

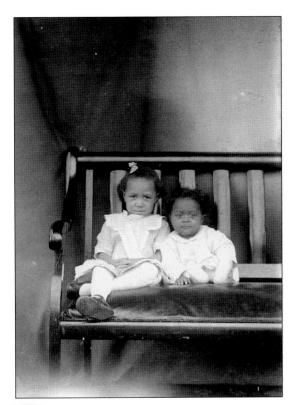

SISTERS AND BROTHERS. The pair of children seated on the fine settee with a leather cushion are probably sister and little brother. The trio crowded on the step is almost certainly two sisters flanking a little brother. The older sister wears a ring.

ORVELLA CLEOTA BANKS. Tiny Orvella Banks (1913–1949) went on to big things with big bands. By age four, Banks played piano. She performed on KFAB radio as a teenager. As with many African American youth, she had educational opportunities in Lincoln, first with a private piano teacher and then at Hampton School of Music, but discrimination limited her employment opportunities. Denied enrollment in Lincoln's musicians' union, she joined up in Minneapolis, then played with Harlan Leonard's big band in Kansas City.

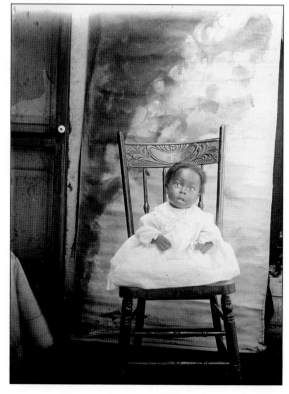

BABY ON A CHAIR. This portrait of a baby catches the hem of a woman's dress at the left edge of the frame, hinting that this youngster was not accustomed to sitting up, especially in a grown-up's chair.

BABY IN A WICKER CHAIR. The chair is woven and the baby's outfit is knit, from head to toe.

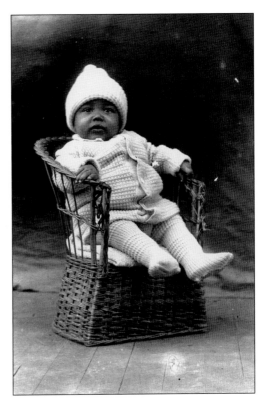

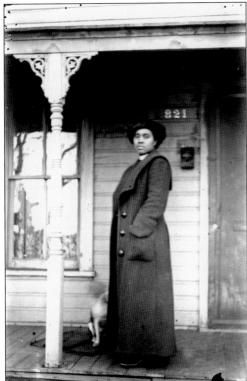

LADY AT NO. 821. This porch is probably 821 S Street, where Abraham and Ellen Corneal lived across the street from Lincoln's Missouri Pacific Railroad depot. Abraham was assistant baggage master. Whether the young woman is a Corneal, or Lena Carriger who lived at the address in 1923, is not known.

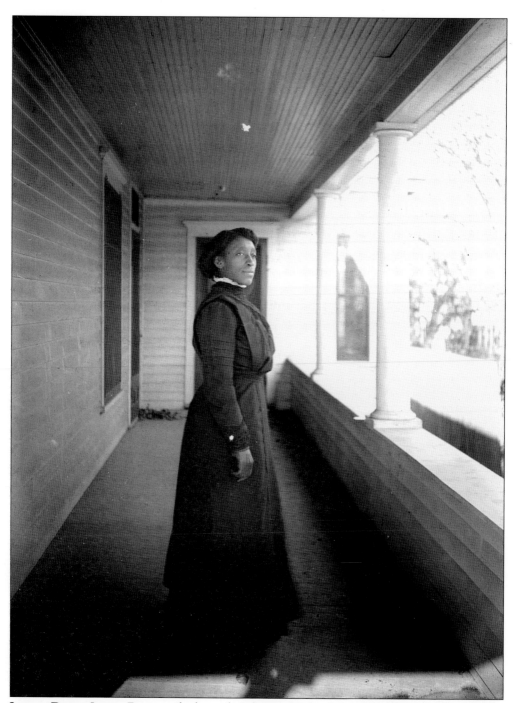

LEONA DEAN. Leona Dean worked as a hairdresser in the downtown shop of Minnie Davis (1862–1949), a white woman. Leona's husband, James (Jim) Dean, worked at Lincoln Country Club and is remembered for providing sought-after part-time work at the club to the men of the African American community, waiting tables at banquets. A half century after their deaths in 1958 and 1959, respectively, Leona and Jim Dean are remembered as leading members of their community.

LEONA DEAN WITH ACCESSORIES.
Even without a studio, John Johnson
endeavored to offer his subjects multiple
portraits, altering poses, accessories,
and solo versus group shots. Various
photographs show Leona Dean with
and without her plumed hat and leather
purse, sitting and standing, in profile and
straight on (see also pages 2 and 96.)
All three views convey her strength
and dignity.

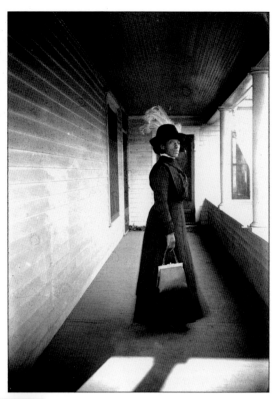

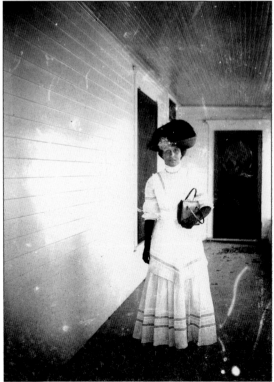

ON THE POSING PORCH. On the same
porch where Leona Dean posed in
black with a distant gaze, this lady in
a crisp white dress peers directly at the
camera. She may be Grace Stanley, who
lived a few blocks away from the Deans
with her husband, Augustus Stanley.
He worked as a waiter and a janitor,
then with Grace opened a restaurant,
barbershop, and beauty parlor at 238
North Ninth Street near the Lincoln
post office. Grace was active at Quinn
Chapel as president of the Treble
Clef Club.

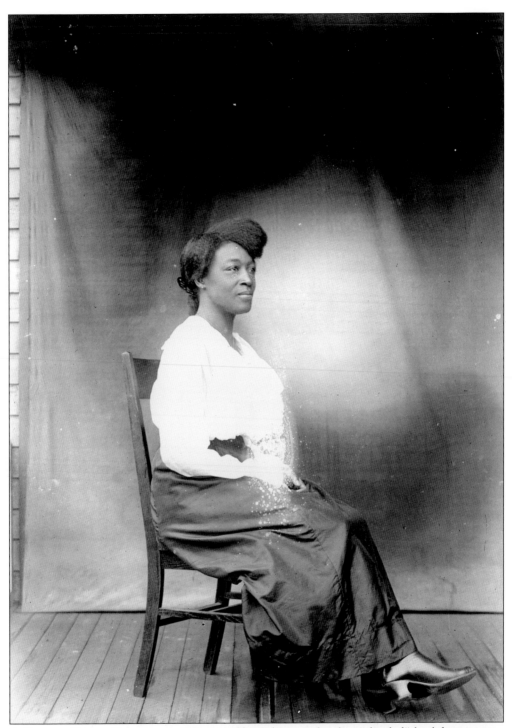

A Pair of Porch Portraits: Casual. John Johnson's familiar "clouded" backdrop turns a porch into a studio for two portraits of a woman, one in blouse and skirt and the other with an added hat and jacket. In both, her posture rivals the straight-backed chair. Her hair is held back with a fine comb, and her crossed ankles nicely display her highly polished button shoes.

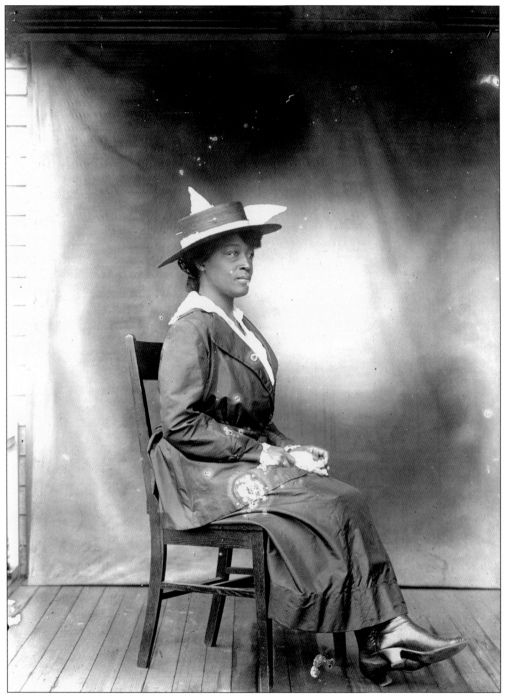

A Pair of Porch Portraits: Formal. A relatively casual portrait is made much more formal by adding a jacket and topping off the ensemble with a dark straw skimmer embellished with white feather wings.

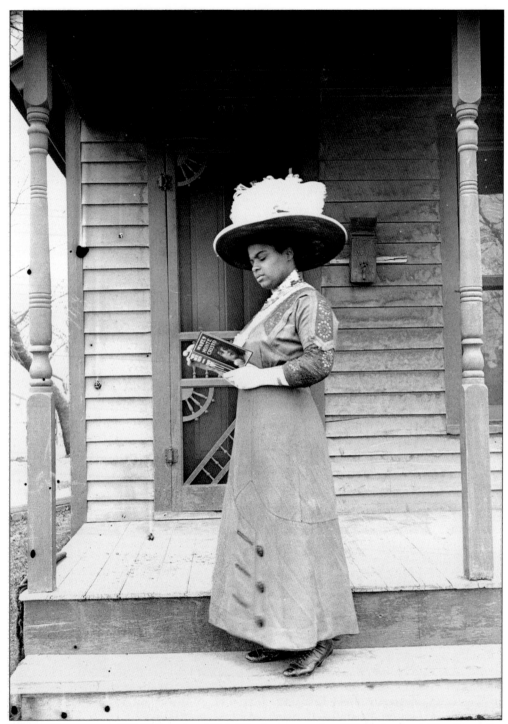

MAMIE GRIFFIN AT 915 U STREET, 1914. The house number 915 is clearly visible above the plumed hat of this well-dressed matron. The close-up view displays the lace detailing of her dress and the title of her book, *The Wife of Monte Cristo*. The book was a sequel (by a different author) to the immensely popular *The Count of Monte Cristo* by Alexandre Dumas.

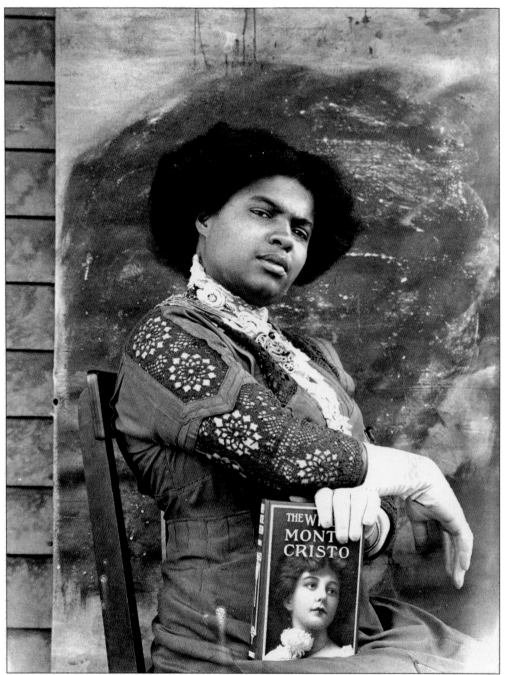

MAMIE GRIFFIN, 1914. The reader is Mamie Griffin, who worked as a cook. Nine decades after the photograph was taken, Ruth Folley recalled Griffin as "a Baptist who sometimes attended Newman Methodist"—her father's church. In 1914, Mamie resided at 915 U Street with her husband, Edward (1883–1939), a waiter at Lincoln Hotel. Their little house and other humble residences stood on a dirt street among railroad tracks and industrial uses north of downtown Lincoln. Far from humble are the dress and demeanor of this woman, posing confidently with her romance novel.

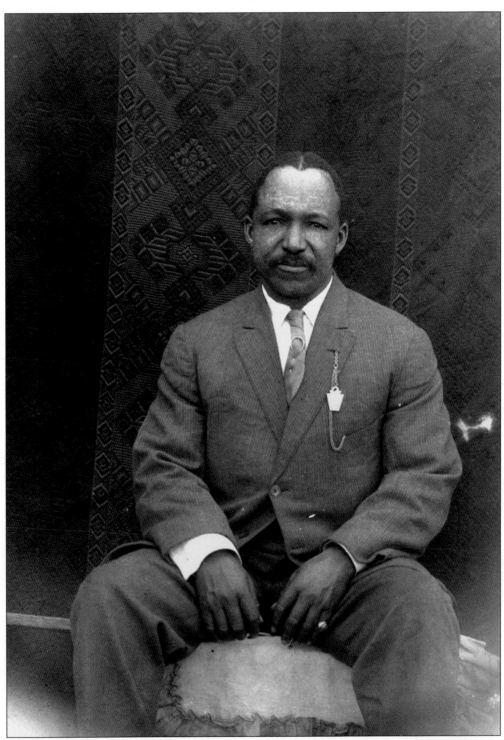

PRINCE HALL MASON. Lincoln's African American community had an organized Masonic lodge by the 1880s, and various Masonic organizations remained active among both men and women throughout the 20th century. This man prominently displays a Masonic emblem.

102

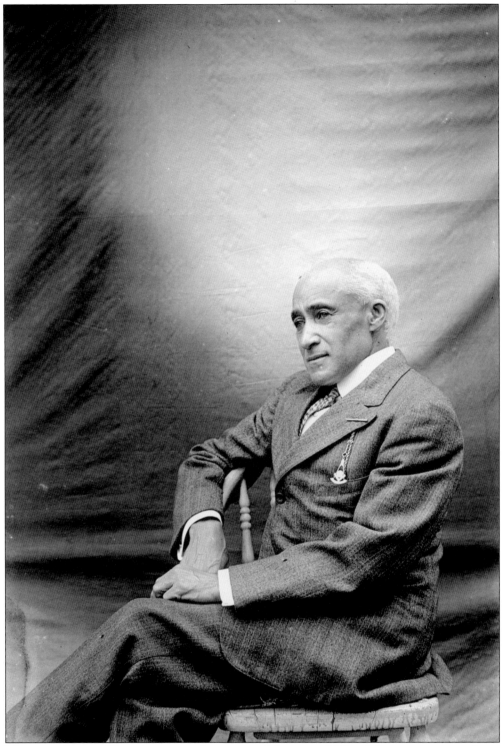

MASONIC ELDER. This elegant gentleman posed for several John Johnson portraits, always displaying his Masonic jewelry.

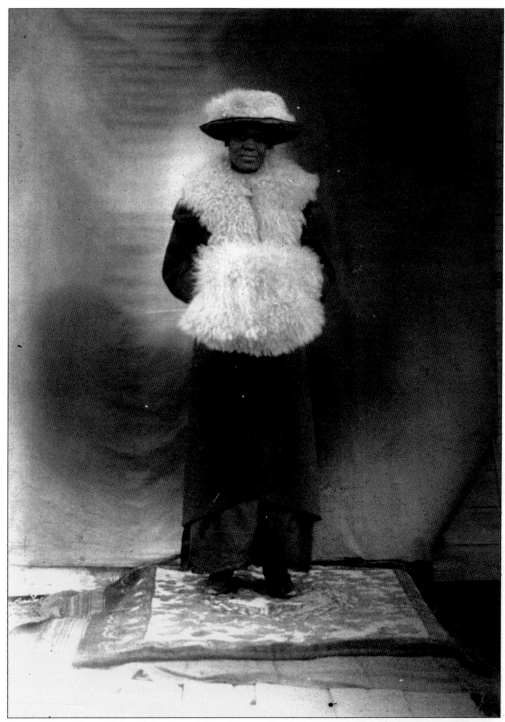

ADDED FUR. One of the women modeling her winter coat on page 82 adds a fur muff and collar to her outfit for this photograph. Horace Colley, son of Walter and Lulu Colley (see cover and page 74), worked as a furrier in Lincoln before and after serving in the U.S. Army as a lieutenant during World War I. Perhaps some of these portraits display his handiwork.

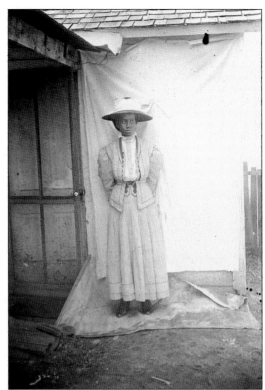

TAILORED ELEGANCE. While the style of the ensembles worn by these two young women are quite different, the portraits are composed very similarly. Both portrait sessions also included second images, without the hats. The image set beside the door demonstrates John Johnson's controlled use of bright shadow, rather than direct sunlight.

ANNA IONA HILL (1886–1944). Anna Hill was born in Kansas, the daughter of Reverend Fulgum, a visiting Methodist minister instrumental in the early years of Lincoln's Newman Methodist Episcopal Church. The new church was founded in 1892 by members from Quinn Chapel African Methodist Episcopal Church. Anna remained a stalwart member of Newman church throughout her life. Her husband, Marshall Hill, was a native of Tennessee.

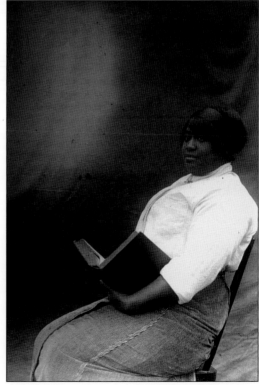

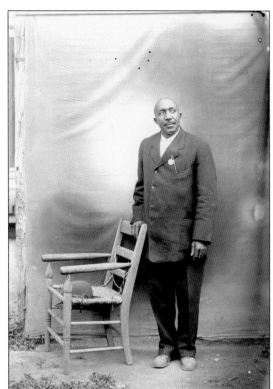

A Gentleman. A worn chair in need of a new cane seat contrasts with a carefully dressed man in neatly pressed trousers. In one image, he chose to pose bareheaded, with his nice hat on the broken chair. In the other, the chair becomes his footrest as he peruses an open book, probably a Bible.

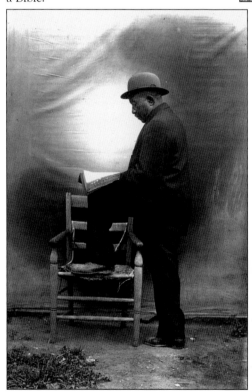

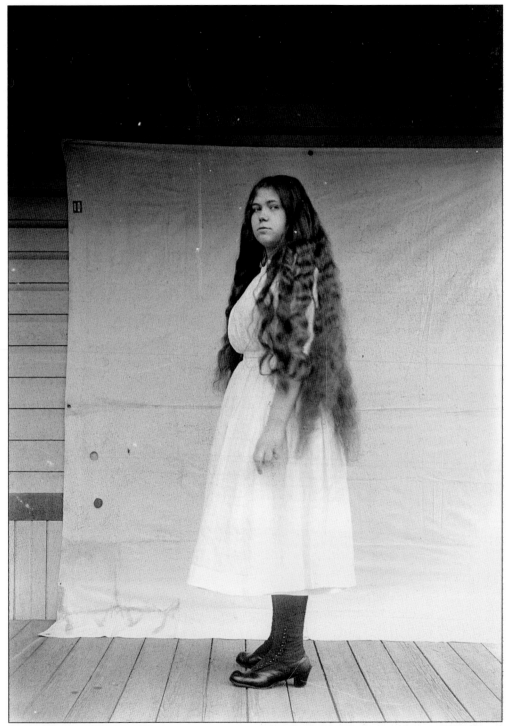

LONG-HAIRED WOMAN. This young woman poses to display her long wavy hair to full effect.

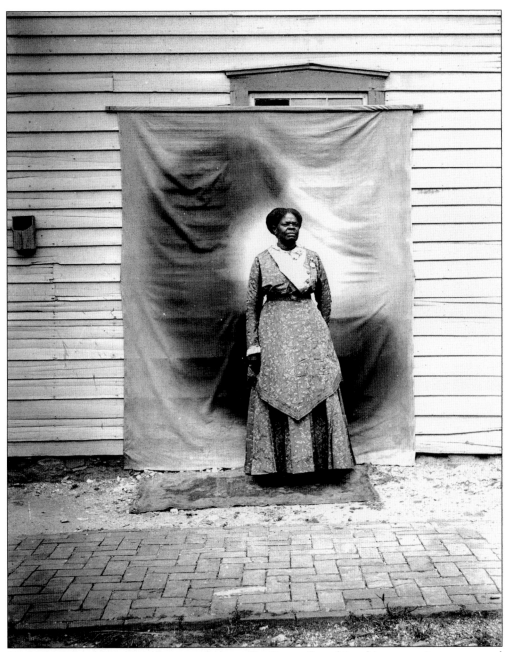

MATRON. John Johnson set his tripod unusually distant from his subject, creating an unusual image in which the wide brick sidewalk and the "clouded" backdrop became vital elements of the composition.

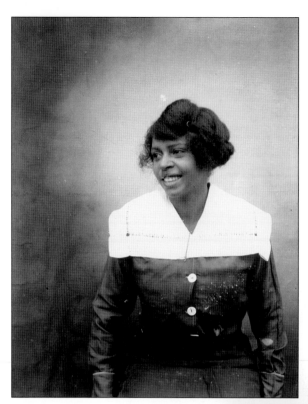

PRETTIER THAN PERFECT. Both portraits of this pretty young woman are in partial profile, with her head turned to the right. The pose de-emphasizes but does not conceal that her upper lip is shaped by a cleft palate.

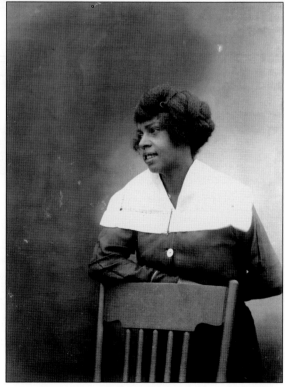

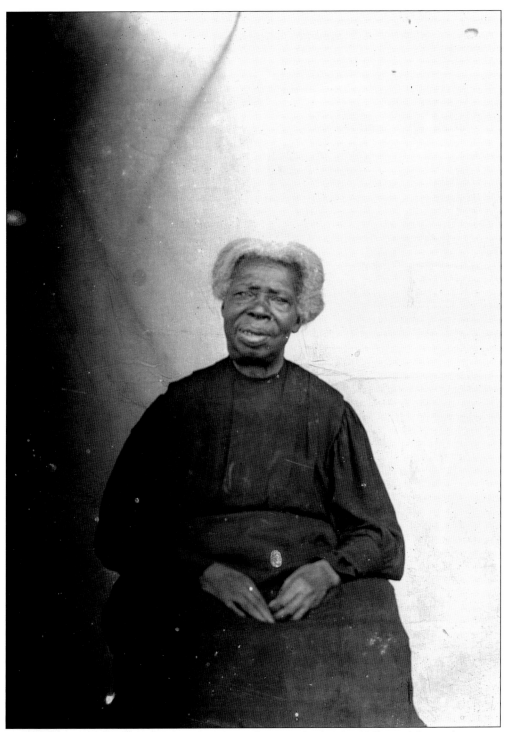

HONORING AN ELDER. In the period of these photographs (1910–1925), an African American of the age of this woman most likely was born in slavery.

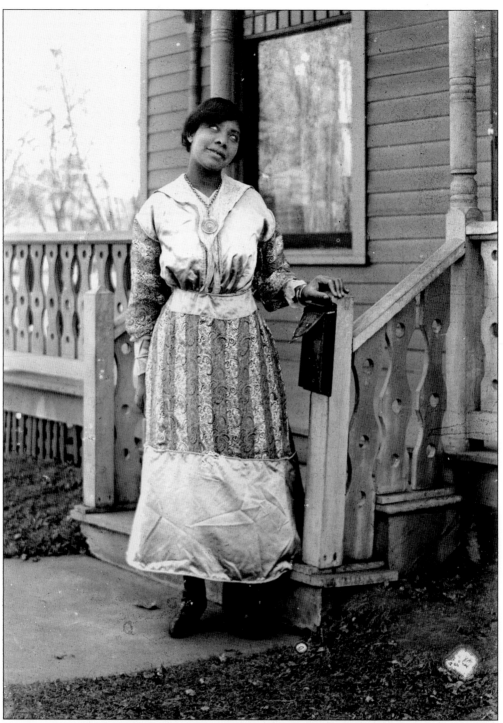

SATIN AND LACE. Fine dressmaking is prominently featured in this portrait of a young woman in a beautiful dress, posing at the steps of a large Queen Anne–style house. She is also pictured on page 62.

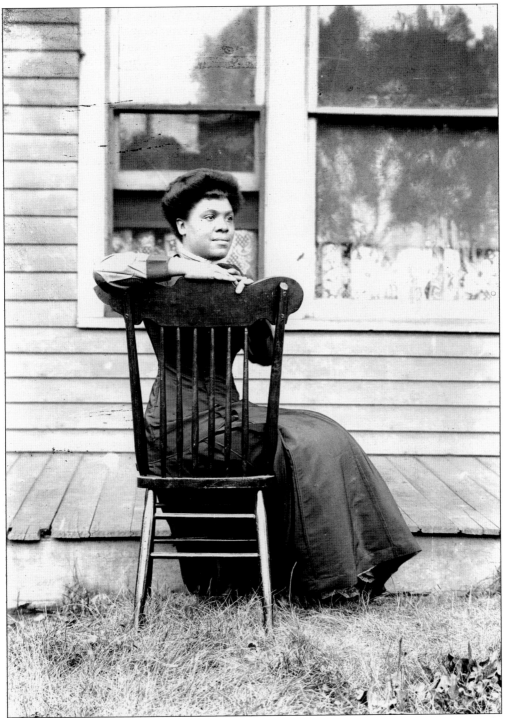

Young Woman. This portrait appears carefully composed to convey casualness, and succeeds.

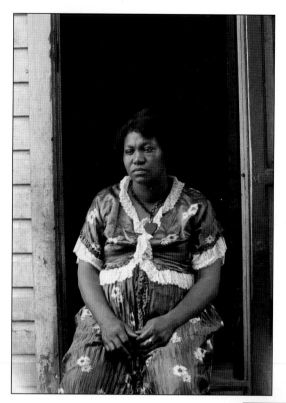

TIRED WOMAN. In posture and facial expression, this woman seems to be merely acquiescing to being photographed. In contrast, most of John Johnson's subjects seem to be active participants in creating their photographic images.

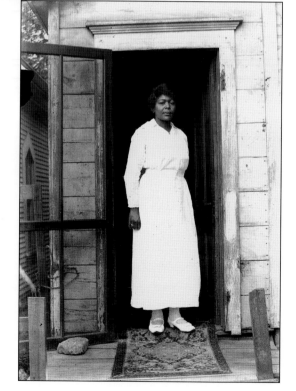

WOMAN IN WHITE. The screen door is propped open with a rock, and a rug has been pulled across the threshold, transforming a simple doorway into a contrasting dark frame for a portrait of a woman in gleaming white.

GENTLEMAN IN SHIRTSLEEVES. A concrete barrier wall protecting a bridge sidewalk provides a seat for a gentleman's portrait, as it also does for the portraits on pages 71 and 116.

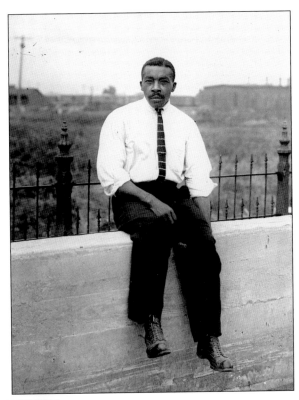

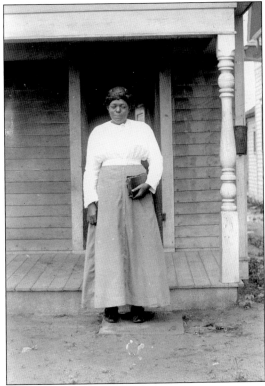

READY FOR CHURCH. Neatly dressed, clutching a hymnal or Bible, this woman appears to be ready to head to church. She may have had a long walk to church as the address 1048 is visible on the wall under the shadow of the porch roof. Probably she lived at 1048 North Seventeenth Street, two miles or more from Mount Zion Baptist, Newman Methodist Episcopal, and Quinn Chapel African Methodist Episcopal Churches. Henry and Anna Coleman lived at that address in 1915, and Henry and Sophia Anderson were listed in 1920.

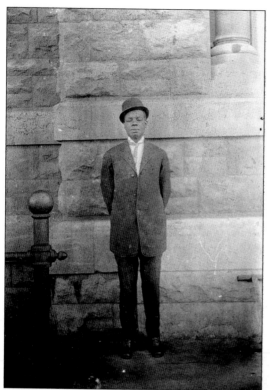

AT (OLD) CITY HALL. The stonework behind this gentleman and the metalwork beside him pinpoint his location alongside city hall, built in 1874–1879 as the U.S. courthouse and post office. It became Lincoln City Hall in 1905, when the new courthouse and post office was built just north of it on Government Square.

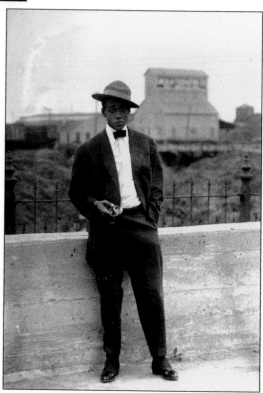

DAKOTA TALBERT. Dapper young Dakota Talbert casually checks his pocket watch. (See also pages 70 and 71.)

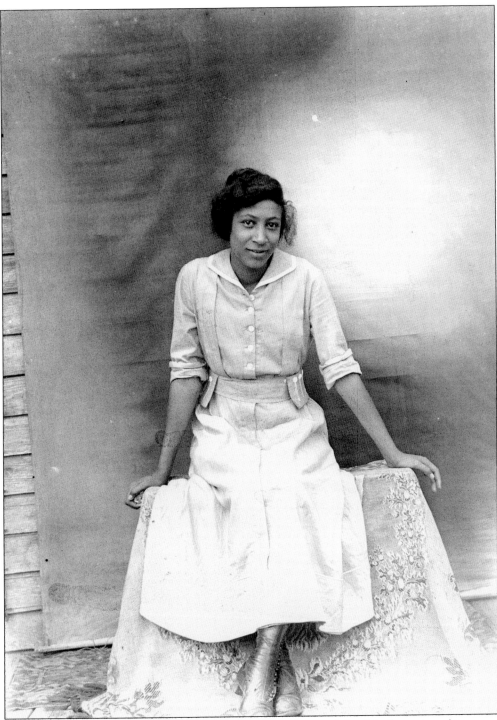

Young Woman in Shirtdress. The continued popularity of the shirtdress gives this young woman a modern air, as does her direct and confident gaze.

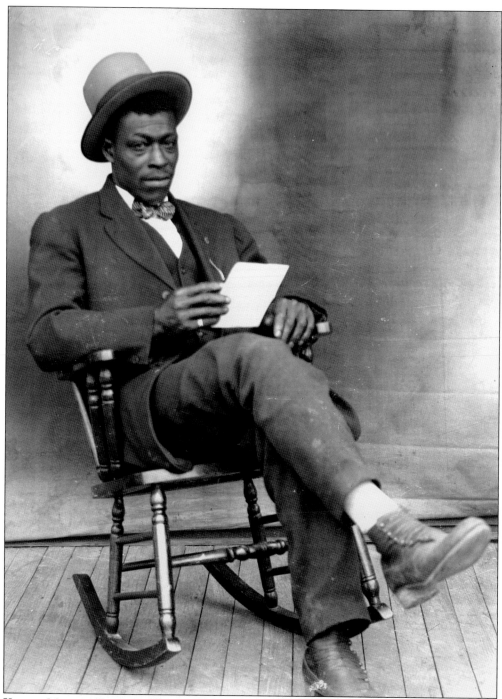

YOUNG MAN IN ROCKER. The simple prop of a piece of paper gives this portrait a sense of alertness or anticipation, despite the man's relaxed pose, tilting back in his rocking chair.

Six

WELCOME INSIDE

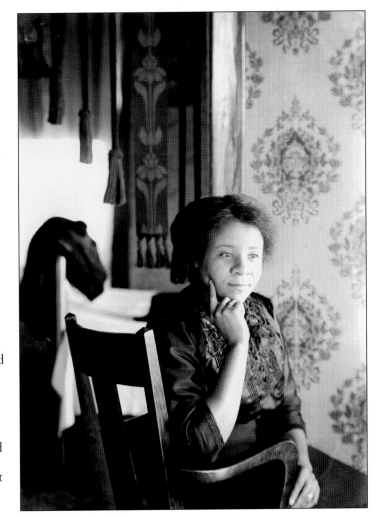

CONTEMPLATIVE FRANCES HILL.
Photographing in homes posed special challenges in the days of bulky view cameras and flash powder. John Johnson apparently took few interior photographs but accomplished some effective images. If the rings on both hands are an indication of marriage, this may be one of the very latest Johnson images. Frances Hill (1904–1932) married Bert Taylor around 1929 or 1930 and moved to New York City, where she died in 1932. This interior is probably in the home of John C. and Mabel Galbreath, with whom Hill lived for most of the 1920s. (See also pages 45, 85, and 120.)

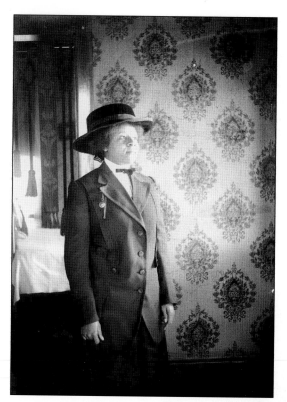

FRANCES HILL. In the same interior seen on page 119, Frances Hill is dressed for going out. Knowing that she went all the way to New York City (and soon died there) makes this image poignant.

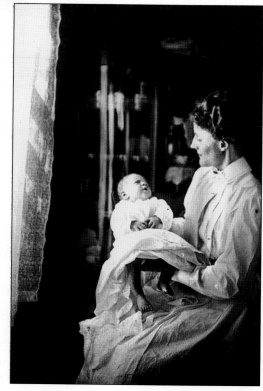

MOTHER AND BABY. Gently lit by the lace-curtained window, this mother and her baby posed for multiple images. Is this the same baby held by its father on page 63?

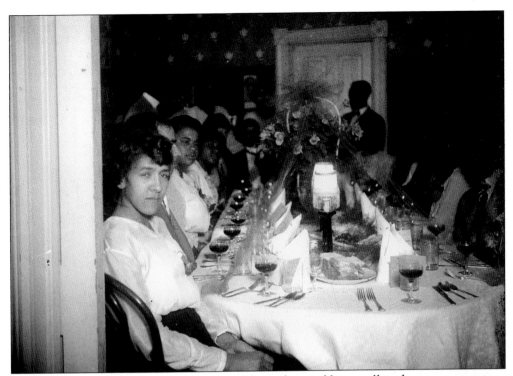

DINNER PARTY. This image records a very elaborately set table, as well as the numerous guests.

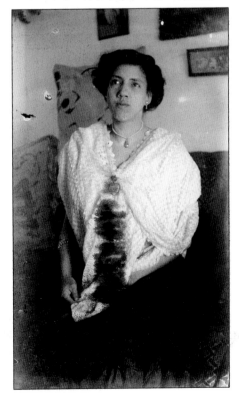

EVA O'DONNELL. This lady in a lace shawl was identified by Pamona Banks James as Eva O'Donnell, daughter of James and Susan O'Donnell. The setting was likely in the house depicted on the bottom of page 42. Eva was in a circle of card-playing friends that included Pamona's mother Ritha Banks and Will Patrick of Hastings, Nebraska. The Patricks were a well-known family of African American homesteaders in central Nebraska. The cardplayers circulated among their homes for games of canasta.

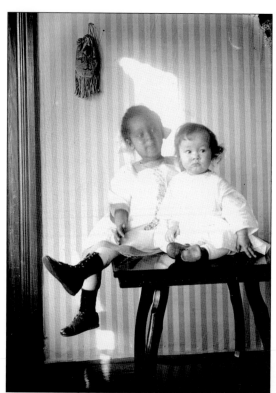

TABLETOP PORTRAIT. A young girl and a toddler pose seated atop a shiny table. The bag pinned to the striped wallpaper may be Native American in origin.

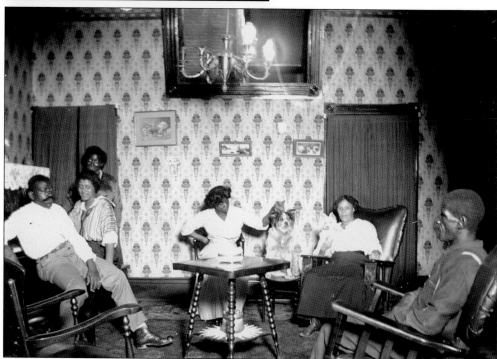

GATHERED IN THE PARLOR. The assortment of chairs and rockers in this high-ceiling room includes a chair for the dog at rear center.

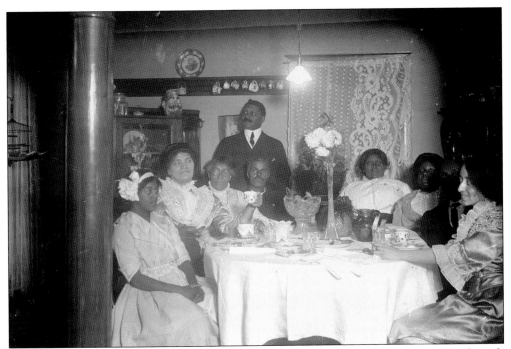

TEA PARTY. The table appears set for tea and punch, not a dinner party. The scene provides rich domestic details, from the pet bird in a cage by the front door at left to the mustachioed vase or stein on the china cabinet in the left rear, next to a mustachioed man.

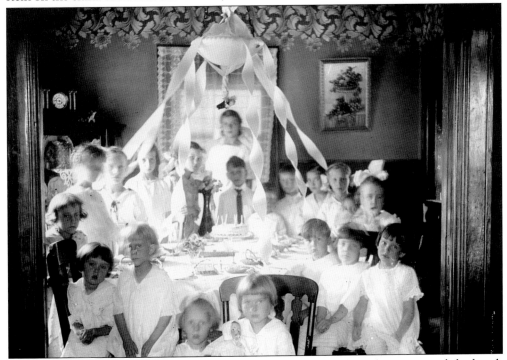

BIRTHDAY PARTY. This image of a children's party appears to have been accomplished with available light.

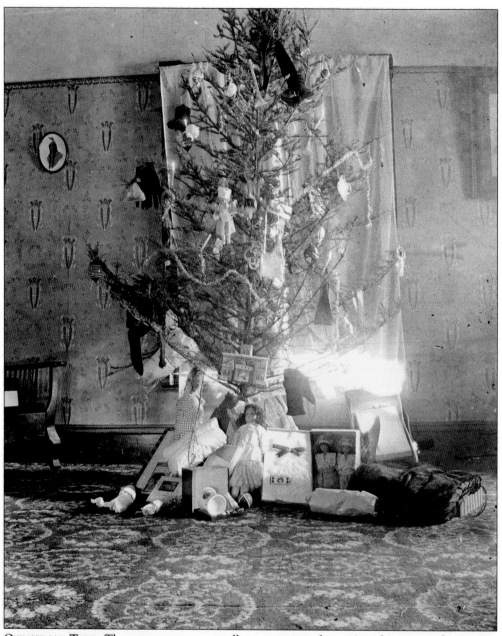

CHRISTMAS TREE. There are presents as well as ornaments decorating this tree, such as a pair of gloves. Among the dolls under the tree are two children's books at left—*Phil the Showman* (published in 1902) and *Frisky Squirrel* (published in 1915).

NOTES ON
THE COLLECTION

In 1965, I was just beginning my experiments with photography, taking snapshots with my parents' Brownie Hawkeye camera and developing the film in the basement. One day, down-the-street neighbors Doug Boilesen and his father, Axel, both avid garage-sale sleuths who were always on the lookout for items relating to Edison phonographs, told me they had purchased, for $15, a stack of old five-by-seven-inch glass-plate negatives. They spied what looked like a picture of a little girl next to a phonograph as well as images of people and downtown Lincoln buildings under construction. I purchased the negatives, minus the picture of the phonograph (which is now in the Friends of the Phonograph image collection) on the time payment plan.

I immediately set out to inventory the collection. I found that there were lots and lots of pictures of people, mostly environmental portraits of Lincoln's black citizens. I put all those in one pile and put all the street scenes in another. With the help of some folks in Lincoln, I was able to determine that the street scenes were taken around 1915. What interested me most was that people actually wanted to buy prints made from those old glass plates. A small flurry of retail transactions followed and my photographic career was launched thanks to some negatives shot by another photographer.

In 1968, the negatives followed me to California, and eventually each of the 276 negatives got its own envelope. Years passed, then in May 1994, my mother, who still resided in Lincoln, noticed a small item in the local newspaper about a researcher at the University of Nebraska who was compiling information on Lincoln's historic African American community. She was informed of a clutch of old photographs in the possession of the McWilliamses, an old African American family, and passed the information to John Carter, a curator at the Nebraska State Historical Society. He was shown 36 five-by-seven-inch glass negatives. In subject matter and style, these photographs strongly resembled the portraits among my early Lincoln images. Local historians pegged the time frame of the photographs around 1910–1925. They also surmised that the photographer might be one Earl McWilliams (1892–1960), an African American who worked part-time in the darkroom at a local photography studio.

I contacted Carter and Lincoln historian Edward F. Zimmer about my collection. In short order, my collection was proclaimed a state treasure. In March 2000, Nebraska governor Mike Johanns honored Earl McWilliams and the McWilliams family in a ceremony at the Nebraska State Capitol.

As time went on, it seems that every discovery about the collection, its subjects, and its photographer led to new questions. When Zimmer and his intern Abigail Anderson were interviewing people who had relatives in the photographs, information came to light that one John Johnson was the likely photographer. We will probably never absolutely know if one person took all the photographs or if they were collaborations. Evidence suggests that at least some of the photographs were collaborations since Johnson appears in some of the images.

Over the years, I have pored over the images looking for a reflection of the photographer in a window or a shiny surface. My search has yielded one shadowy image reflected in a brass doorknob and one image of the photographer's or his helper's hand. That image was taken at a zoo. The photographer prefocused the camera on a wire fence then either he or his helper held out his hand with a piece of food and enticed a deer to come and nibble. At the precise instant the deer got to the wire the photographer squeezed the shutter. That image may be the only image of the photographer we will ever have. However, what we will always have is an extraordinary collection of images produced by an astoundingly capable hand.

—Douglas Keister, Chico, California

REACHING THE PHONOGRAPH.
A little girl stands proudly next to a brand-new Edison C-150 Sheraton design phonograph. The phonograph was introduced in June 1915 and manufactured until 1918. It was a very popular model and became Edison's second-best seller in 1917.

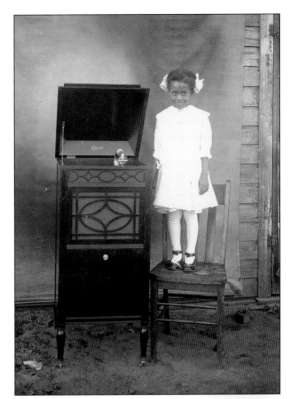

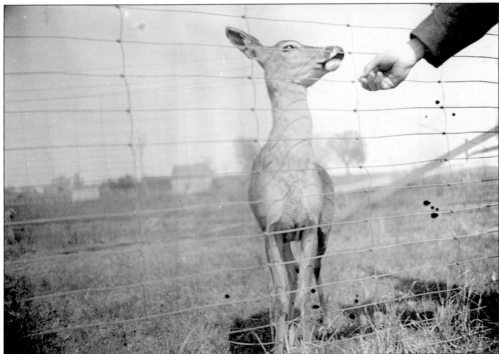

OFFERING A HANDOUT. The photographer or his helper offered a piece of food to a deer then snapped the shutter.

ACROSS AMERICA, PEOPLE ARE DISCOVERING SOMETHING WONDERFUL. *THEIR HERITAGE.*

Arcadia Publishing is the leading local history publisher in the United States. With more than 3,000 titles in print and hundreds of new titles released every year, Arcadia has extensive specialized experience chronicling the history of communities and celebrating America's hidden stories, bringing to life the people, places, and events from the past. To discover the history of other communities across the nation, please visit:

www.arcadiapublishing.com

Customized search tools allow you to find regional history books about the town where you grew up, the cities where your friends and family live, the town where your parents met, or even that retirement spot you've been dreaming about.